GOAT TAILS AND DOODLEBUGS

A Journey Toward Art

written and illustrated by

Everett Gee Jackson

**Dedicated to my great-granddaughter
Rebecca Brantley Waterman**

San Diego State University Press
San Diego State University
San Diego, California 92182

Book design and typesetting by Sheila Dollente

Manufactured in the United States of America
ISBN: 1-879691-18-3 trade
ISBN: 1-879691-19-1 limited

PUBLISHER'S ACKNOWLEDGMENT

San Diego State University Press is pleased to publish this work written and illustrated by Everett Gee Jackson. The stories related here are among the formative events to Everett Jackson's tenure as Professor of Art at San Diego State University from 1930 to 1963.

In expression of the high regard in which Everett Jackson is held in the University community and the greater community of San Diego, the persons named below have generously contributed their support which made possible this publication. At the request of the author, proceeds from the book will benefit the Art Department at SDSU.

San Diego State University Press acknowledges with profound appreciation these donors.

Benefactors

Dr. John R. Adams

Mrs. Henry G. Fenton (Justine)

The J. W. Sefton Foundation
Thomas W. Sefton, President

Sponsors

Mr. and Mrs. Frank D. Alessio (Linda)

The San Diego Museum of Art
Steven L. Brezzo, Executive Director

Mr. and Mrs. Hugh C. Carter (Pat)

Mr. and Mrs. Howard L. Chernoff (Melva)

Mr. and Mrs. J. Dallas Clark (Mary)

Dr. and Mrs. James E. Crouch (Mary)

Mr. Thomas J. Fleming

Mrs. Theodor S. Geisel (Audrey)

Mrs. Robert M. Golden (Connie)

Mrs. Leon R. Hubbard, Jr. (Betty Marshall)

Mr. and Mrs. Payne Johnson (Linda)

Mr. and Mrs. Philip M. Klauber (Detty June, posthumously)

Mr. and Mrs. S. Falck Nielsen (Charlotte)

Mr. and Mrs. George M. Pardee, Jr. (Kathy)

Dr. and Mrs. Norman C. Roberts (Gelín)

Mrs. Deborah Szekely

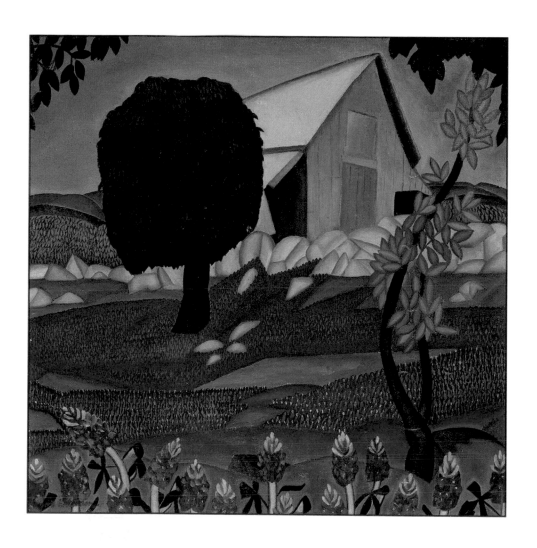

Texas Bluebonnets

TABLE OF CONTENTS

Preface x

I. Early Days 1

II. My Hometown 25

III. Animals in Our Family 39

IV. Girls 49

V. High School 55

VI. Aggieland 79

VII. The Devils River 99

VIII. The Rio Grande and the Pecos 129

IX. Back to A&M 155

X. The Art Institute of Chicago 167

XI. Oil Boom in Mexia 189

XII. California 199

XIII. Return to Mexico 217

XIV. Camping on the Sabinas 229

LIST OF COLOR PLATES

1. *Texas Bluebonnets* v
2. *Spring in San Diego* 215
3. *Cotton Pickers, East Texas* 253
4. *Cora Alexander's Cabin* 254

LIST OF ILLUSTRATIONS

1. *Argoo said we should run away from home* 1
2. *I, a boy child, wore dresses* 2
3. *Doodlebug, doodlebug, you better come home* 6
4. *The salamander* 7
5. *Traynham Pitts walks the fence* 9
6. *John Corley fights the bumblebee* 14
7. *The River Jordan runs into the Red Sea* 18
8. *The houses were not crowded together in my hometown* 25
9. *Flowers for Josephine* 26
10. *Jack Atkinson was careless* 30
11. *After that, Jack Johnson's head was on sideways* 39
12. *Jack Johnson was careless* 41
13. *Billy chases Traynham Pitts* 46
14. *It became obvious that girls were different from boys* 49
15. *The tardy bell was very slow to ring* 55
16. *Repairing the "Victory of Samothrace"* 59
17. *Mrs. Focke in the barn lot* 66

18. *Old Useless fought from the rear* 70

19. *With Mississippi in the pit I felt sure I would qualify* 79

20. *"Pootch, Fish!"* 83

21. *Traynham would get the shakes at every cattle guard* 99

22. *Prairedog town* 103

23. *Our camp on the Devils River* 107

24. *Sky Dunnagan* 110

25. *Paul Gee comes down to swim* 126

26. *West Texas seemed to belong only to God* 129

27. *At the time, I thought it was a logical idea* 131

28. *The sleepwalker* 135

29. *Traynham buys a cowboy hat* 137

30. *If it were not for the drilling, A&M would be paradise* 155

31. *The lines of descriptive geometry* 161

32. *Travel by coal-burning train* 167

33. *Coco scampers up the curtain* 174

35. *A gushing oil well was a common sight* 189

36. *The honkytonk in Mexia, Texas* 193

37. *To California by train* 199

38. *Mexican rural architecture was pleasing to the eye* 217

39. *Francisco Carranza* 222

40. *José with Nacimiento over the hill* 227

41. *Black girls joined in with the Kickapoo dancers* 229

42. *Poete had a backlash* 231

43. *The "Hunter's Den"* 247

44. *Lowell's Burro* 250

PREFACE

In my two books, *Burros and Paintbrushes* (Texas A&M University Press, 1985) and *It's a Long Road to Comondú* (Texas A&M University Press, 1987), I have told the story of my experiences painting in Mexico from 1923 to 1972. In my third book, *Four Trips to Antiquity* (San Diego State University Press, 1991), I have described my experiences in Central America, where I went to paint and to study the form in ancient Maya sculpture. In a sense, those three books are memoirs. Considered as memoirs they deal with much of my life, but not with my earliest years.

During the process of recalling the events that took place in those three books, I began to wonder if there might be a significant connection between my earliest life and my decision to pursue the art of painting. Shortly after this question had come

to mind, I received an invitation that encouraged me to search for the answer to that question. The president of the Historical Society of San Diego, California, asked me if I would speak to that group on the subject "The Evolution of My Art." I thanked him and answered that I had never given any more thought to the evolution of my art than I had given to the evolution of my feet, but that I would think about his kind invitation and let him know.

When I began to recall the earliest events of my Texas childhood, with the evolution of my painting in mind, it occurred to me that perhaps I should try to write another book. I decided to write one that would start as far back in time as I could remember and continue until 1923, when my first book, *Burros and Paintbrushes,* began. This book, which I call *Goat Tails and Doodlebugs,* is the result of my decision.

CHAPTER I

Early Days

At the beginning of my conscious life, I, a boy child, wore dresses. I now know my mother made them, but at that early age I did not know I was wearing that kind of clothing. One of my cousins pointed it out to me. I did not even know I was a boy. I played with my cousin Argoo, although I did not know she was my cousin. I did not know she was a girl, either. Since she was about my age, I suppose she did not know I was a boy.

It was my cousin Argoo who said to me one day that we ought to run away. She was nearly five years old then, and I was going on four. So we ran away from home together. We started

1

going down the dirt road that was out in front of our houses. We kept going down that road until we got into strange country. I remember I liked everything I was seeing. The wind was blowing, and the high grass was quivering on all sides. There were tall poles along the road, and high up above there were wires on the poles. We went on and on down the road without talking. I remember thinking, "We are running away from home because Argoo says it is the only thing to do." We must have gone down that road a whole block before we were caught. I don't know where Argoo went after we had to come home, but that did not bother me. I knew she was somewhere.

It may have been that same day that Argoo's older brother, Jack Jackson, came up to me while I was playing on our front porch. He said to me, "You are a little girl, aren't you? You are a little girl because you wear dresses."

I looked down and saw what I was wearing. It was something that covered me and hung down almost to my bare feet. It hung straight down, and it was what I always had worn. I remember I looked at Jack to see what he was covered with. He had on *two* dresses, one on each leg. I now believe it was at that moment that I began to realize I had been a boy all along and that I should wear a dress on each leg.

All of what I write above is true to my memory, and it is also clear and unmistakable. But if I try to go back to an even earlier time in my life, I find only short snatches, even though they also are quite clear. One involves my sister who, much later, became known to me as "Esther." She said to me, "Look out the window and see a rabbit running." I looked, but I did not

see a rabbit. I saw only light. I now assume it was the sky I saw outside the window. Esther kept trying to make me see a rabbit, but, try as hard as I could, all I saw was the sky.

Esther also tried to make me see a house we were going to move to, way across the railroad tracks. She would point and say, "See it over yonder! It has a red roof. Can't you see it way over yonder?" I looked and looked, but I never saw that house, which was to be my next home.

Later, after we had moved to that house, my brother, whom I knew only as one of those who was always around, took me upstairs and went with me into a small closet and closed the door. It was dark inside. Then he did something, and everything became very light. The light had a center with little light lines in it. My brother Hal, I now know, was introducing me to a wonderful thing called an electric light. I remember well how Hal smiled as he would look at me and switch the light bulb on and off.

* * *

When I think about what I remember of my very early times, it is obvious that my memory salvaged only certain events and allowed the others to go by. Things must have been happening to me every moment of my life, but my memory only recorded certain events. It may be that everything was recorded, but in such a way that many events remain hidden. Perhaps my memory is structurally like a lot of storage rooms, some of whose doors got stuck over the years, so that the contents of those

4

rooms can't get out. I have heard the expression "jog your memory." Perhaps if I knew how to jog those stuck doors, I might find myself with a flood of new memories of my very early times.

Benvenuto Cellini tells in his autobiography that at the age of five years he saw a salamander in the family fireplace. The salamander *I* saw came up out of a doodlebug hole when I was about that same age.

It must have been a short time after we had moved to our new house when my sister Esther took me down the cinder pathway past the smokehouse to our barn. On each side of that barn, and connected to it, was a shed-like room. The floors in both sheds were of dirt, and it was on one of those dirt floors that she showed me how doodlebugs could be found. She showed me how one could make a doodlebug emerge from his home by stirring the soft dirt with a stick while singing these words:

> Doodlebug, doodlebug,
> Come out of your home.
> Your house is on fire,
> And your children will burn.

If one kept singing those words and kept stirring, eventually the doodlebug would appear in the dirt. I remember what a gray and strangely shaped creature the little doodlebug was. He was the same color as the dirt he lived in, and when I saw him moving about in the gray dirt I had a great desire to take him out and give him a bath. But something told me that that would not be at all what a doodlebug would like.

One day I went alone down to that shed where the doodle-bugs lived. I got a little stick, and while stirring in the dirt as I sat in my long dress, I began singing the doodlebug song. But before the doodlebug arrived I got a different idea. I happened to have a little spoon in my long dress pocket. I had put it there after I had finished eating cornbread from my glass of butter-milk. Since I had a spoon with me, I decided to dig down into the doodlebug home. I started digging spoonful after spoonful of gray dirt. I must have made a hole about three inches deep. I remember my conscience was hurting me a little bit. I had a feeling that I should not be destroying the doodlebug's home.

Suddenly I was horrified when there rose up out of the hole what I am now inclined to believe was a salamander. He was a little fellow about three inches tall. He was wearing a bright red coat. He looked up at me with a terribly angry expression on his face, and he waved his arms about. He was obviously telling me to quit digging. His lips moved rapidly, although no sound came out. But I knew what he meant, and I was very frightened. I got up from the dirt floor and ran.

I have thought of that incident many times over the years, and I have wondered what that little creature could have been. Although it now seems impossible that that incident could have occurred, it has nevertheless been placed permanently in one of the rooms of my memory. I suppose I shall never know, for sure, what it was that came up out of that doodlebug hole, but when I refuse to use my reason something tells me that it was nothing else but a salamander, And the bright-red coat he was wearing was actually fire.

* * *

One day, while I was playing on the front porch of our new house, I saw a man going down our alley toward the barn. I ran fast into the house and watched him through our front-room window. I knew who he was, and that is why I ran.

After a while I saw him coming back. This time he had a big tow sack on his back. He was the tamale man, Martínez, the one who had once scared me so bad I had wet my britches. That was when my mother was buying some of his tamales, and I had reached around and touched the red rag on his tamale bucket.

When our school gave the Battle of the Alamo on the school grounds, I had to play dead because a Mexican had shot me. My teacher told me that when the battle started all I had to do was fall down and pretend I was dead. Martínez was the only Mexican I had ever seen, and I continued to be afraid of him.

Afterwards, when he would go down our alley to the barn to get corn shucks, he would wave at me and smile. But that did not make us friends. I knew I could not talk to him even if he was all right. My mother told me he spoke a different language. I often wondered where he came from. I imagined everybody looked like him at the place he came from. Someday, when I grew up, I knew I would want to go and see that place where Martínez came from.

* * *

Our new house was set back from the street. It had a large front yard filled with big trees. A picket fence with a gate and two tall gateposts separated our yard from the sidewalk just

beyond. Another day when I was playing on our front porch, a woman and a boy came along the sidewalk. The boy had on a brown derby hat. To this day it amuses me that the boy, at such an early age, was wearing a brown derby hat.

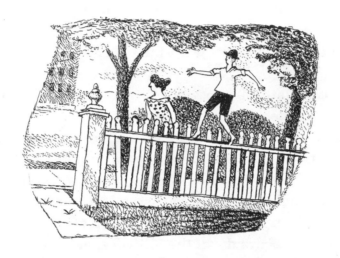

The woman and the boy walked past our house, then turned around and walked past again. They did that several times while I sat on the porch and stared at them. Then the little boy did a shocking thing. He climbed onto the top of the fence and began walking along the two-by-four to which the pickets were nailed, balancing himself with his arms outstretched. He walked the entire length of our fence, turned around, and, without falling off, walked all the way back. The woman followed along with him. I thought to myself that anybody who could walk on the top of our fence like that was all right, so I went out

to the gate. The woman said she was his sister, Bertha, and that
the boy's name was Traynham Pitts. Traynham then said the
pin he was wearing he had won for not missing Sunday school. I
remember that didn't impress me, because I didn't like to go to
Sunday school. It was too hard to get ready for it. I did not tell
Traynham my name, because it was a nickname. I would answer
to it, but I never liked it and I did not want to spread it around.
That is still true, although I was able to lose it when I came to
California.

Sometime later, I went with Traynham to where he lived.
His house was a block away from our house. It was on a street
corner. By the side of his house a sidewalk ran steeply down a
hill for about two blocks. At the bottom of the hill the sidewalk
crossed a deep ditch. Traynham showed me a wagon he had
made out of a single board and four small wheels. I think he had
found the wheels in that ditch at the bottom of the hill. He said
he could ride that board down the hill very fast. He also said not
everybody would know how to ride his wagon down the hill. I
remember wondering, "Why not?" It looked simple enough to me.
The front wheels of his wagon were attached by wires to a stick
that lay across the front end of the board. That was the steering
stick.

I didn't ride his board that day, but later, when I went up
to his house and found he wasn't at home, I saw that he had left
his wagon in his front yard. I decided to ride it down the hill. The
sidewalk went straight. There was no turn in it until near the
bottom, where it crossed the deep ditch. When I got to that turn,
I was going very fast, and the board was veering to the right. I

10

knew I would have to turn the stick to the left to keep from landing in the ditch. But when I turned the stick to the left, the wagon went sharply to the right instead. I landed in that deep ditch and cut my wrist on a tin can. Traynham had arranged the steering stick on his board so that if you wanted to go to the right you had to turn the steering stick to the left. I now knew why he said not everyone would know how to ride his wagon. I also learned a lesson about Traynham Pitts. That was the way he was in his approach to many things.

That year, Traynham came to our house almost all the time. When Christmas was near he spent many nights at our house, and on Christmas Eve he hung his long stocking alongside mine and that of my younger sister, whose nickname was Queen. The stockings hung down from the mantelpiece in front of the fireplace in my parents' room.

The next morning we were up before daylight. When we went into that room to see if Santa Claus had brought us anything, we were stunned to find that he had left Traynham and me each an Indian suit with feathered headdress and an air gun with BB shot for ammunition. On the wooden stocks of each gun were the words "500-shot Daisy." My mother read those words to us.

We put on our Indian suits and headdresses, took up our guns, and even though it was not yet daylight, started up the street looking for some enemy to shoot. Nobody was out, anyplace. But when we came to the street corner near Traynham's house, the streetlight was burning brightly up above the street crossing, hanging there on wires. Traynham looked up at the

streetlight, pointed his gun at it, and yelled wildly, "500-shot Daisy!" He pulled the trigger and shot out the light. I could see the pieces of glass from the light bulb falling all around. I was proud of him, and now knew he was a fine shot with an air rifle. Neither of us told anybody about Traynham's achievement in shooting out that streetlight.

A few days later, during broad daylight, I climbed up a walnut tree that grew just outside our dining room. I had on my Indian suit and feathered headdress, and also I had my air gun with me. I looked down and saw my older brother Hal coming up the path from the smokehouse. But as he came nearer, to my surprise, he was no longer Hal. He had turned into another Indian, and I knew he was a Comanche, my enemy, since I was an Apache. I drew careful aim and fired my air gun. As it turned out, I hit that Indian in the left ear lobe. He yelled like a Comanche Indian, but right before my eyes he changed back to Hal again. And now, although he was no longer an Indian, I knew he was still my enemy, so I got down from the tree and ran. I circled around the house and scampered under it. I kept crawling until I was far up near the front steps. I knew he would not follow me into such a cramped place. Later, when I ventured out, he had cooled off and was not mad at me. But the BB shot had stuck in his ear lobe. He showed me where he had pulled it out. He said, "Dad gum you, Beency!" (That was my nickname.) But he didn't stay mad at me. Maybe he knew I had mistaken him for a Comanche Indian.

*　　*　　*

Down the street in the opposite direction from Traynham's house lived a boy named John Corley. The first time I met him he said to me, "When I grow up, I'm going to be a carpenter and build lots of houses. I am building a house now in the backyard."

I went with John to his backyard and found that he really was building a house. It wasn't very big—only about three feet high. He had used the side of a shed as the back of his house. He had built the sides out from there. John had a sawhorse, a hammer, plenty of nails, and a saw. He put a board on the sawhorse and said to me, "You can never build a house until you know how to saw a straight line."

He then proceeded to show me, taking the saw and making a cut that was as crooked as a dog's hind leg. I thought to myself, "You'll never build a house sawing that way." But John took that board with the crooked end and nailed it to his house.

A few days later I went down to John's home to see the bumblebees' nest he had found at the point where his house joined the shed. The bumblebees were flying out of that place, one at a time, while others were coming from somewhere else and going into the nest.

Up the side street from John's home lived a Norwegian boy named Babe. He must have been at least twelve years old— maybe older. John told me Babe had made two paddles out of shingles and had shown John how he could fight the bumblebees. If you stood just in front of the place where the bumblebees came out, a bee would fly at you. You then had to hit him with your paddle. But if the bee got past your paddle—if you missed him—he would really go after you, and if he caught up with you

that was too bad. He would sting you. A bumblebee sting is very painful.

John showed me the two paddles and said, "I'll show you how you do it." He also said, "If the bumblebee does get through, you have to run as fast as you can, and if you see the bee is about to catch up with you, the thing to do is throw your cap down. The bee will follow the cap down to the ground and sting it instead of you."

"All right," I said, "show me."

So John stood in front of the bumblebee nest and, just as he had said, a bumblebee came out of the hole and went straight at him. John started swinging both paddles furiously, fanning the air so fast the bee was shoved to the side by the wind. But he never hit the bee, and in no time I saw John beating a fast retreat with the bumblebee right behind him and catching up fast.

I yelled at John, "Look out! He's right behind your head!"

At that point, off came John's cap, and it sailed toward the ground. I was fascinated to see the bee quit chasing John and fly instead into his cap, staying with it all the way to the ground.

"He got by me that time," John said, "but he didn't sting me, because of my cap!"

I told John that I would think about using his paddles for a while before I tackled a bee. I said that I thought I had better practice swinging the paddles first.

John went over and retrieved his cap, which had saved him from a bad sting. He placed it on his head and was ready for another sortie. But just before he got back to his station, with a paddle in each hand, suddenly, to my horror, he let out a terrible yell and began tearing his cap off his head.

It turned out that the bumblebee was about as smart as John at this game. He had remained in John's cap, waiting for him to put it on again. When he did, the bee finished what he had intended to do earlier: he gave John a bad sting on top of the head.

* * *

John was always saying he was going to build so many houses when he grew up that I began to wonder what I was going to do when I grew up. I didn't think I could build a house, ever. My oldest sister, Nettie Floyd, had given me some watercolors once, and she asked me to make a picture of a banana. She put a banana on a plate and said, "Now see if you can look at the banana and make one just like it."

I had seen bananas before, but I had never looked at one. I began to draw this one. It was pretty ripe and had long lines of dark brown on one side, so I put those dark lines on top of the yellow. I didn't like the way the brown and yellow ran together. I didn't like my picture much, but my sister said it was very good. She even pinned it on the wall.

After that, when John would start telling me about all those houses he was going to build, I would say, "When I grow up, I am going to make pictures of bananas and other things."

"What other things?" John once asked me.

"Well," I said, "I'm going to make pictures of chickens, too."

After telling John that, I began to look at my mother's chickens. I had seen them, too, but I had never looked at them before. I began to draw chickens while I was looking at them, even though they were always moving around. I also got to hating chickens almost. When you look at them they are not at all nice. They are always pecking each other, and they are very stupid.

Anyway, I kept on drawing chickens, off and on, for a long time, although I never was sure I would want to draw them when I grew up. I would have to wait and see. But I kept telling John that was what I was going to do when I became a man.

* * *

Not long after that bumblebee stung John, I started going to school. My teacher in the first grade was Miss Betty Burson, whom I remember as quite an old woman. She asked each of us the first day if we could count to a hundred. A boy in front of me counted to a hundred very fast. His name was William Norman. But when she asked me, I said, "Twenty, maybe, but not a whole hundred." So I was put with the group that couldn't count to a hundred. I remembered that my friend Jaky Gentry couldn't count very high either. He owned a hog, and when I asked him once how many ears of corn he fed his hog, he said, "I feed my hog two ears of corn and then another one, every morning and night." Even so, Jaky was then in the third grade.

On that first day of school, Miss Betty got all the boys together and said she was going to ask a favor. She said she was going to ask us to promise her we would never, never smoke a cigarette until we reached the age of twenty-one. All of us promised her, and I never forgot that promise. I did try to smoke a homemade cigarette or two that we made with corn silk, but I did not consider those cigarettes real cigarettes. To this day I have never smoked cigarettes because of my promise to Miss Betty Burson.

Miss Betty Burson must have been very religious, for about all I can remember learning in her class was that the River Jordan ran into the Dead Sea. She would draw that river on the blackboard—a long, white chalk line that ended in a white pocket at the bottom. That pocket was the Dead Sea.

Traynham Pitts was in a class ahead of me, so for a long time I never saw him where I went during recess. Then one day during recess a big boy named Rudolph Nawlin started picking on me. I had been staring at him because he was so ugly, and he must have seen me. He came up to me and gave me a blow on the shoulder. He was much bigger than I was, but I didn't hesitate to hit him back. When I did that he came at me with both fists, and we started to fight in earnest. I was clearly getting licked, when, to my surprise, Traynham Pitts stepped up out of nowhere. Traynham said to me, "Let me take over now." He stepped between me and Rudolph. Rudolph accepted his new opponent without letting up. His two arms were flailing like a windmill at Traynham, but Traynham knew just how to get inside those blows. In no time at all he had Rudolph flat on the ground. He put his foot on Rudolph's neck and said, "Say 'Calf rope!' Say 'Calf rope!'" Rudolph then said feebly, "Calf rope," and Traynham let him get up.

18

Fortunately, no teacher saw this three-way fight, so that was the end of it. It was not permissible to fight on the school grounds, although I did have two fights later on, and one of them was on the school grounds. The other one was with William Norman, behind the Presbyterian church.

A boy threw a rock on the playing yard one day, and the rock skipped along and hit me on the shin. The boy who threw the rock wasn't throwing at me. In fact, he wasn't throwing at anybody, but he shouldn't have been throwing rocks among all the kids playing there. Anyway, it bounced up and hit me on the shin, and it hurt very much. It made me mad, so I went immediately to the thrower and landed several good blows on him. That time I got caught. A teacher saw me and reported me to the principal, a man by the name of Perkins, whose nose always seemed to be stopped up. I had to report to his office. When I went in I was surprised to find John Corley there, too. Apparently he had been caught fighting some other place. Mr. Perkins made John and me put our heads out the second-story window of his office. He then pulled the window down on our necks, and as we gazed at what was going on down on the playground outside, he gave us both a good paddling inside. It really didn't hurt, but I felt embarrassed nevertheless. But I didn't feel at all guilty.

The other fight, behind the Presbyterian church, was more like a duel. William Norman was my good friend, but he kept saying that he thought he could whip me. I saw no reason to be fighting a friend, but he kept telling me that we ought to have a fight to see who could win. One afternoon, he even told other kids we were going to fight behind the church and that they

could come and watch it if they wanted to. He seemed to want an audience. I did not see any point in a fight with somebody I wasn't mad at, but it appeared to me there was no way to get out of it. So we went back behind the church after school that day, and quite a crowd of boys went along with us.

William and I faced each other, and he hit me first. That started me swinging. We really went at it. I don't know how long it lasted, but when it was over both of us had our shirts nearly torn to shreds. The fight must have been a draw. William then went home with me, and when we got to my home we must have looked pretty messed up because my mother got out two new shirts, one for William and one for me. After we had both washed our faces and put on the shirts, she gave us each a big dish of homemade ice cream. William spent that night with me, and we went to school together the next morning. We were always close friends after that fight—maybe closer than before.

When my two older brothers heard about all the scrapping I had been doing at school, they came to me and said they were surprised. They said they couldn't understand it, because whenever they had been in a fight situation they had always run instead. Hal said he and my brother Ben were both "fleet of foot."

* * *

One day when Traynham Pitts and I had just come home from Sunday school, we found some of our friends down behind our old gray barn. We started making corn-silk cigarettes together but soon got tired of trying to light them, so when

Traynham said he bet he could piss higher than any of us, we all accepted his challenge. I had no idea about my ability, since it had never occurred to me to try for altitude.

We all lined up facing the gray board wall of the barn, and Traynham went first. He stepped forward a foot or two, and after shouting "Stand back, you guys!" he stood sort of sideways. It looked to me as though he was aiming at the moon. Then he swung around suddenly with both hands on his pecker. When he let go, I saw a fine stream shoot upward. It hit a spot at least twelve feet up the barn wall and then trickled down, slowly spreading out as it soaked into the dry board. I knew I could never reach that height, so I didn't even try. Some of the other boys made what appeared to me to be feeble attempts, but not one came anywhere near what Traynham had achieved. His triumph seemed to put a damper on everybody else's spirit. We all now started wandering up the alley toward Miss Betty Johnson's house. Because of what had happened, I began to sing a song I had heard my Grandpa Eubank sing:

> I'm gonna git me some sticks
> To build my chimney higher;
> To keep them Johnson gals
> From pissing out my fire.

On the right side of the alley there was a picket fence about eight feet high. It had three or four strands of wire from top to bottom woven around the slats of the fence. The slats were only about an inch apart. As we walked up the alley next to that

fence, Miss Betty Johnson's little short-haired black dog named Roger kept going along with us on his side of the fence, barking furiously at us. We all hated that dog and wished we had some way to kill him. But all we could do was throw rocks at him, and always the rocks would hit the slats and bounce back. We never could seem to throw a rock between those slats and hit Roger. And the more rocks we threw at him the worse he would bark at us. He knew he was protected by that fence.

As we continued on up the alley, we saw John Corley coming toward us. He was carrying an air rifle.

"What you got there?" Traynham asked John when he came up to us. "That doesn't look like any air gun I ever saw."

"It's not," John said. "It's a *pump* air gun. You have to pump it up. If you pump it enough, it will shoot as hard as a twenty-two."

Of course we all knew that was just what we needed for Roger. But by that time we had walked up the alley until we were next to Miss Betty Johnson's house. We knew she was probably sitting at one of the windows of her house watching everything we were doing. It would be necessary to get old Roger to go back down the fence toward the barn.

Traynham said to John, "Let me see that gun. How do you pump it up?"

John showed him that you had to pull a long metal rod out of the end of the gun, right under the barrel, and then push it back again. This had to be done several times for each shot, and the more times the rod was pulled out and shoved back in, the harder the gun would shoot.

Traynham now whispered to John, so Miss Betty wouldn't hear, and asked him if we could use the gun to shoot Roger. John hated that dog as much as we did. It was that dog that almost got him caught stealing peaches off one of Miss Betty Johnson's peach trees the summer before. When John had gone over that fence way down at the end of her orchard, Roger had started barking louder than ever before. John saw Miss Betty coming that day and got back over the fence before she was able to see who he was. So now John said to Traynham, "Sure, but let me do the shooting."

After talking it over, though, we all agreed that Traynham should do the shooting. We felt that since he could piss so high he must also be a good shot with a rifle. I also remembered that on Christmas morning he had shot out a street light.

Traynham got the gun from John and started pumping it up. "I'm gonna pump this thing up," he said, "until it will shoot through an iron door." He kept pulling the rod out and pushing it back in until it became hard to push back in. Traynham then put the end of the rod against the house and put his entire body against the gun. We knew it would now shoot hard, because it just couldn't be pumped up any more.

We all got together now and started walking down the alley very close to the fence to make Roger mad, and we were delighted that he kept coming along down the alley with us toward the barn. Finally, when he was so far down we thought Miss Betty couldn't hear him barking, we stationed John Corley up where he could watch to see that she was not coming our way.

Roger was rearing up against the fence, standing on his hind legs and barking as though he hated us all. Traynham backed off about fifteen feet from the fence until he was almost against the barn. He knelt down and began to take aim. We were all very silent.

John Quinn said at that point, "Good-bye, Roger. It was shore nice knowing you."

That made me start feeling sorry for Roger. I was thinking that, after all, you can't keep a dog from barking. And besides, he couldn't hurt anybody; he was so small. I think the other boys felt sorry, too. One of them turned around and wouldn't even look. Then we watched Traynham hunker down again and adjust the gun to his shoulder. He took a deep breath. We all knew Roger was about to take a long trip to Dog Heaven, since the gun was pumped so tight.

Traynham pulled the trigger. We saw, almost immediately, a red chip of wood fly off the fence at least seven feet above Roger's head. Traynham Pitts had missed!

"What did you shove me for?" he said angrily.

I never did believe anybody shoved Traynham, but in any case, he missed Roger clean. We never did try to shoot Roger after that.

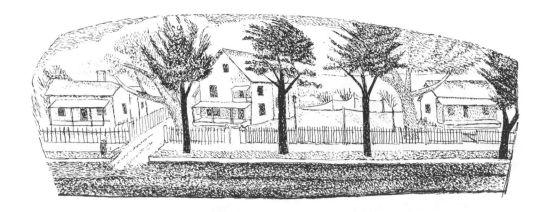

CHAPTER II

My Hometown

Unlike Caesar's Gaul, my hometown—Mexia, Texas—was divided into five parts, at least all the time I was living there. The nicest, by far, was the main residential part with its many Victorian houses and large front yards filled with trees and flowering shrubs.

The commercial part, along Commerce Street, was quite small, with its better shops, stores, and the barbershop. In the earliest period, there was an impressive fountain where Commerce Street crossed Sherman Street. Nobody in Mexia to this day would say that street was named after General Sherman, a Yankee.

Over to the west, across the H & T C railroad track and beginning just beyond the Commercial Hotel, was what we called "Freedman Town." That was where nearly all the black people lived, although in those days they were called Negroes, not blacks. In fact, they would not have liked it at all if they had been referred to as blacks.

Freedman Town was for me a mysterious place. It was where I knew I did not belong, even though I had a kind feeling for black people, especially for one black man named Paul Gee. I knew he had once belonged to one of my relatives in Virginia. He now lived with us, and I considered him a close member of our family. During the ginning season he had a permanent job working the press at my father's cotton gin. When the gin was not running, Paul would do such jobs as bringing in wood for the kitchen stove. For a while Paul Gee also milked the cow each morning, but my mother made him stop that because often she would find cow manure in the milk bucket. Paul said the manure got in the bucket when the cow switched her dirty tail around.

Whenever he wanted, Paul would wander into our parlor and, with one finger, play tunes on our upright piano. One tune he liked to play and sing had these words:

> I wouldn't marry an old maid;
> I'll tell you the reason why:
> Her neck's so long and stringy
> I'd be afraid she'd never die.

Another one he sang was this:

> Railroad, **plank** road,
> Tennessee Canal,
> If it hadn't been for Liza Jane
> There wouldn't have been no Hell.

Another black person who was often at our house was Mary Tatum. She came once a week and did the family washing. I was always fascinated by her because my mother told me that when I was an infant and she was sick, she had turned me over to Mary Tatum to nurse. She said I thrived on Mary's milk. I had a peculiar feeling about having lived for a while on a black woman's milk. That may have been one of the reasons I could never develop any race prejudice against blacks.

But despite my close acquaintance with and affection for the blacks who were often at our house, I realized that Freedman Town was off limits for me. I also felt there was something basically wrong about those people living together so isolated from the people in the other part of town for whom they came over to do the cooking and the housework. For me, however, it was just a fact of life, even though distasteful.

The fourth part of my hometown was the graveyard, bordering on the north, at a higher elevation. That was where all the dead people had moved. They were there living quietly together in their own part of town, even more isolated than the people of Freedman. I learned at an early age that an invisible

battle was going on constantly in our town, even though we never knew who was fighting in it until someone would die and have to live in the graveyard. There must have been, somewhere, a black graveyard, but I never knew where it was. At times I suspected the black people were not taking part in that invisible battle, and therefore never died. They didn't seem to get any older either.

The first one of my friends to fall in that battle was Adrian Kendrick, whom I knew in the first grade. He was a member of that group which couldn't, at first, count to a hundred. One day Miss Betty Burson, our teacher, told us he would not be coming back to·school. She told us never to carry into the house more stove wood than we could carry at one time. She said we should make more trips with just one or two pieces each trip and not try to carry it all at once. I assumed from that that Adrian must have strained something. But I really knew he had fallen in that constant and invisible battle that was going on in our town.

It was a great blow to me when another person fell. Her name was Josephine Klotz. We were in the third grade together. To me she was very special because of the way she could draw trees. She could draw wintertime trees with no leaves, springtime trees, and summertime trees, and she drew very directly, without ever hesitating. She would put her pencil point on the paper and draw the trees without ever needing to erase. She gave me some of the drawings, and I valued them highly.

Josephine was not my girl, but she almost was. I admired her blue eyes and her delicate, slightly brownish fingers as she

drew. When our teacher told the class Josephine would not be coming back because of diphtheria, I felt that I wanted to do something about it. I got John Corley to go with me and pick some flowers. We took them to our teacher and told her they were for Josephine Klotz. We knew Josephine would, from now on, be with all those people at the graveyard.

The fifth part of our town was the boneyard. It was where all the bones from the slaughterhouse were scattered about. I never did see that place, but Jaky Gentry told me about it. He went there to get the bones he was so good at clicking in both hands. He told me that cow bones, including cow skulls with holes in their foreheads, were all over the place. I could imagine it, but I never did go there to see it. I always assumed it was somewhere beyond the Mexia graveyard.

Perhaps it should be mentioned that a small part of the graveyard had an iron fence around it and was exclusively for Jews. I had a Jewish friend named Henry Nussbaum, whom I liked very much. I used to look at him and think that one of these days he would probably take up residence in that Jewish part of the Mexia graveyard, behind the iron fence.

29

* * *

In our town, while I lived there, crime was a most exceptional thing. People were never afraid during day or night. They did not lock their doors because everybody felt secure. No one thought of hurting anyone else.

In our town, the Methodists pitied the Baptists for having made the mistake of choosing to be Baptists, but they really didn't dislike them. Even my own steady girl friend was a Baptist. She played the piano for the Wednesday prayer meetings, and I often went with her. But being a Methodist, I would usually sleep during the service. The Baptists, it seemed to me, almost disliked the Methodists, but not quite. In our town during those times, there simply were no Catholics and no Christian Scientists.

The black people did not hate the whites, even though they had good reason to, and the whites were fond of the blacks as long as they "kept in their place."

Within this almost constant harmony, however, there were sporadic exceptions, and on rare occasions there was violence of the worst sort. In our town of about 2,500 people, I only knew of two drunkards. Mr. Mayo, who lived down the street from our house, was one. I often saw him staggering home in the late afternoon. But despite his wild meandering from one side of the sidewalk to the other, he never fell down. He always made it home. I used to wonder how things were among his family, for he had two of the most beautiful and lovable daughters, both of whom were in my high-school class. Those charming girls were

named Gladys and Pauline, and Gladys had the prettiest neck I had ever seen on any human being. Because of those girls, I felt sure Mr. Mayo had to be a fine gentleman despite his overindulgence.

The other drunkard in town was Jack Atkinson. He seemed to be a bachelor, since I never saw any evidence that would suggest he had a family. However, he did have what surely must have been the longest mustache in all of Texas. When you met him walking sober on the street, which he did on rare occasions, you could almost have mistaken him for a longhorn steer, such was the broad spread of his mustache. But at one point in his life his mustache spread out in only one direction and on one side.

One Sunday morning when I was walking home from church with my father, we took a shortcut through the grounds of my father's cotton gin. There, spread out on the place where the cotton wagons were weighed, was Jack Atkinson, sound asleep and completely out because of the whiskey he had just consumed. An empty quart bottle of Old Sunnybrook lay by his side. My father found a sandstone rock nearby, gently raised Jack's head, and placed the stone under it as a pillow. My father then told me this story.

Jack Atkinson, it seems, upon awakening from such a sound sleep one day, found that one side of his elegant mustache was completely missing. Someone had neatly removed it with a razor after Jack had passed out. When Jack waked up, he must have felt so off balance that he tended to fall to one side. When he realized what had happened, he made some inquiries and

learned the identity of the one who had dehorned him so grotesquely. He also learned the address of this man, who had moved on to Dallas. Jack told my father that after he had learned the necessary details, he "caught the first freight train north." A few days later Jack returned to Mexia, clean-shaven. But the man who had so dishonored him never came back to the scene of his crime.

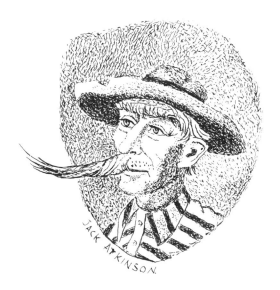

Over many, many years, there were only two murders in our town. When I was about six years old, I heard the gruesome story about Beverley Wood. He had gotten into a quarrel with another man in a saloon on Main Street, and to settle the quarrel he had "slit the other man's throat from ear to ear." No more murders occurred thereafter until I was in high school.

By that time there lived in our town a man named Henry Spillers, who made his living in a way only a comparatively few people understood. This man had formerly been sent to the penitentiary for murdering a black woman up in the graveyard, but for some legal reason he had been set free. He then came back to our town. Nearly everyone knew he was present. Everyone would see him from time to time on the street, and everyone had the feeling that he was dangerous. Mostly, people wondered about how he made a living.

One day while he was playing poker in the basement of a store on Commerce Street, he shot and killed one of his fellow card players. He then ran out into the street just as a black man was driving by in a truck. Henry Spillers jumped onto the running board of the truck, pushed a pistol against the head of the driver, and ordered him to get out of town fast. The driver speeded up and drove out of town on the Teague Pike. When they reached the end of the pike, about five miles from town, Spillers jumped off the running board of the truck and ran into a nearby forest of oak trees. So many people in the street had seen his flight, as he rode on the running board of the truck with his gun pressed against the head of the black driver, that the local police were well aware of the situation. Also, the driver, who a short time before had been black but was now quite pale, soon returned in his truck with all the details from his point of view.

The town constable knew where to look for Henry Spillers; however, when the local citizens suggested that he had better get started, he said, "I am a married man and I have a family to provide for. I just can't afford to take a chance on capturing that

dangerous man. I hope you understand." In the end, the police department of Waco, Texas, fifty miles away, was called on the telephone and given all the details. Before nightfall two officers and one bloodhound arrived from that small city. Soon Henry Spillers was located, captured, and taken away. He had offered no resistance. He was never again seen on the streets of our town.

Now that Henry Spillers was gone, news of his way of making a living soon leaked out. It became known that he had had a collection route. For months he had been going into different stores along Commerce Street to collect his weekly fee from the owners of those stores.

"I have come to collect my weekly fee of ten dollars," he would say.

"Oh, yes, Mr. Spillers; it is about that time, isn't it?" And they would give him the money. John Corley's father, who ran a furniture store, was said to have been one of Henry Spiller's clients.

*　　*　　*

When I try to remember anything that might be labeled "the crime of burglary" in my hometown, I come up with only one event, and even it can barely fall into that category. Once, in the dead of night, I awakened to find the electric light of my room shining brightly into my eyes. My older brother Hal, my two sisters, and my mother were talking in whispers at the foot of my bed. My mother and my sisters were dressed in their night-

gowns, and my brother had in his hands a big stick of firewood which he had picked up near the fireplace.

I soon learned that they had been awakened by noises downstairs, noises that indicated somebody was in our kitchen. Fortunately, our kitchen was at the far west end of our house, downstairs, and we were in a room at the east end, upstairs. A large dining room and two hallways separated the kitchen from our front door. A stairway led from upstairs down to our front entrance hall. At the bottom of the stairs and attached to the wall was our telephone. That telephone was about as far away from our kitchen as it was possible to be and still be in the house.

My mother now whispered, "I am going down to the telephone and call Mr. Walter Lewis." To do that, she would have to be on the same level with the burglar in the kitchen. Mr. Lewis was at that time the town constable, but he retired soon after and did not have that job later when Henry Spillers ran amuck.

When my mother announced that she was going down to the telephone, my sisters grabbed onto her nightgown and wouldn't let go. They seemed to feel secure as long as she was near them.

We could still hear noises down in the kitchen. When my mother started moving toward the stairway, three of my sisters were hanging onto her nightgown. After jumping out of bed in my BVDs, I also had managed to get a grip on one part of that garment. My mother, my sisters, and I now started moving toward the stairs as one body, while my brother Hal brought up

the rear with his big stick of firewood. He thought that stick
would be a good weapon.

We all tiptoed down to the telephone, and my mother
lifted the receiver. When the operator said, "Number, please,"
my mother whispered Mr. Lewis's number. When Mr. Lewis
answered, she told him who she was and informed him that a
burglar was in our kitchen. Then she hung up.

"He will be here in a few minutes," she whispered to us.
Mr. Lewis's home was just one block away. He lived across the
street from Traynham Pitts's home.

One of my sisters now whispered, "Mama, let's go back
upstairs." But my mother said we had better stay where we
were. Of course the front door was unlocked, just like all the
other entrances to our house. Nobody in our town ever locked the
doors to his house in those times.

Soon Mr. Walter Lewis arrived. He was a big man, about
six feet four or five inches tall. My mother whispered and
pointed toward the kitchen. Mr. Lewis now started in that direc-
tion, going through the hallway that led into the dining room
and then to the next hallway and on into the kitchen. We were
all so close behind him he could never have retreated without
falling over us, if a retreat had been necessary.

When we entered the kitchen behind him, we saw that the
electric light was still on. The burglar had escaped.

Looking at the big kitchen table, we all saw a large white
dish, and in the middle of that dish was one dark piece of fried
home-cured sausage with a bite taken out of it. Mr. Lewis picked

it up and said, "Well, I'm glad he left me this piece, anyway," and he popped it into his mouth.

As it turned out, the burglar was really a tramp, and he had entered our kitchen only because he was hungry. He had helped himself to a plate full of biscuits and a big dish of home-cured sausage. Looking in the icebox, my mother discovered that he had also drunk a whole pitcher of buttermilk.

My brother Hal threw his stick of firewood onto the pile of stove wood in the kitchen, my mother thanked Mr. Lewis, and we all went back upstairs to our beds.

CHAPTER III

Animals in Our Family

As I was walking home from my third-grade class at school one day, a little black puppy suddenly joined me, wagging his tail and acting as though he knew me. I had already reached our front yard, so I picked him up and took him into the house. From that very moment, he seemed to know that he belonged to me.

When my father came home and saw the puppy, he liked him almost as much as I did. "What is your little dog's name?" he asked me.

I said I didn't know yet, that he had just taken up with me when I was coming from school.

My father said he thought a good name for him would be "Useless." "Let's just call him 'Useless,'" he said.

From then on that was my dog's name. He had short black hair, and he was very smart and active. He became my devoted companion from then on. He began to grow up with me.

Everybody in our family loved Useless except maybe my oldest brother, Ben. Actually, there were times when he hated Useless and would have liked to kill him. When my brother was mad at Useless, I would hide the little dog under the house until my brother cooled off.

Useless had a bad habit of causing a running person to fall flat on his face. My brother Ben started running up the street one day, and old Useless watched him until he was going full speed. Then he took out after him. When Useless caught up, he ran past my brother so close he pushed both of Ben's feet out from under him. That caused my brother to have a hard fall.

"You son of a bitch!" he yelled. But before Ben had time to get to his feet, Useless had already circled back to the house and gone under it. My brother got a big stick and asked, "Where is that bastard? I'm going to kill him." I knew where he was, because I had taught Useless where to go and hide.

We always had cats around at our house, too. They also took up with us, for no one would ever think of going out to look for or to buy a cat. My father would often buy a bird dog, but he certainly would never have stooped to buying a cat. At this time we had a black cat named Jack Johnson.

One day when my brother Hal was home, he asked Paul Gee and me to help him push our old Hupmobile out of the shed next to the barn where it was kept. That car wasn't used much, because my father had not made the full transition from horse and mule power to automobile power. But Hal liked to drive it, so Paul Gee and I went along to help him get it out of the shed.

I can't imagine a cat being so careless, but when the car started moving it ran over Jack Johnson's head. He let out a terrifying scream. To this day, I can see that cat with his head under the tire and his black body and long black tail thrashing the air next to the wheel. Hal yelled for Paul and me to push the car off the cat's head. Unfortunately, Hal was pushing against us, so the car was stalled for some time before we could get the cat loose. When we finally did get Jack Johnson's head from under the wheel, we found that his neck was broken. We thought sure that black cat would die. But Hal took such good and constant care of him that he lived. After that, though, Jack Johnson always walked with his head turned completely to one side. If you looked down on him from above and said, "Kitty, kitty," he would turn his head the rest of the way around and look up at you and meow. No other cat could do a thing like that.

* * *

In those early days, we had a variety of animals, but except for Useless there was none as family-like as my mother's old bay mare named Satin. I think she got that name because her coat of hair shone like satin. I feel sure she knew every member of our family by name. She also knew she was my mother's animal and that she was supposed to pull my mother's four-wheel vehicle which we called a phaeton.

When my mother wanted to go shopping up town, it was my job to catch old Satin and hitch her up to mama's phaeton. I would take the bridle and go down to the pasture beyond the barn, but I knew ahead of time what would take place. The same thing always happened when I was the one to catch old Satin. She would see me coming, and she would say to herself, "Here comes Beency to get me, but I am going to give him a chase first." So as I approached her she would suddenly whirl and run very fast to the other end of the pasture. I would walk all the way down there, and she would then stand still and let me put the bridle on her. But if I sent my sister Esther to get her for me, old Satin wouldn't run at all. I think she loved Esther, and I certainly know Esther loved all animals.

When I would get Satin up to the barn and start putting the harness on her, she would stand still until I started to buckle her belly band. Then she would manage somehow to swell her belly up like a balloon. I would tighten the belly band as tight as I could, but when I left, her belly would immediately shrink and the belly band would then be sagging four inches clear of her

belly. I would just let it go and hope the harness wouldn't fall off while my mother was driving her to town.

Unfortunately, Satin must have been a glutton. She was always well fed, and she looked almost overweight. One night, after we had had old Satin for years and years, someone left the barn door open where the corn was kept. Old Satin went into that place. She must have kept eating all night long. The next morning, we found her all swelled up and stone dead. She died, but she surely didn't die hungry.

The mules in our family seemed like distant cousins, or even like servants. They lived only to work, most of the time at regular hours. During ginning season, their job was to haul a big wagon from my father's cotton gin to the mill across town. Back and forth they would go, carrying cottonseed to the mill and then returning for another load. At the mill the seed was made into cottonseed oil and cottonseed meal. In the late afternoon those mules would be driven back to our barn lot, smelly, sweaty, and no doubt very tired. Grover Graves, the driver, would feed them after they had taken a long drink from the watering trough, which was full of water with long strings of green, slimy algae growing in it.

When the cotton-ginning season was over, the mules had no work to do, and it was then that my friends and I would often ride them bareback around town. The mule population in our barn lot was variable. I think my father would sometimes send a couple of those mules to the ranch, eighteen miles north of Mexia, and have a different pair brought back. Once he brought two gray mules, and they turned out to be very gentle and easy

to ride. I knew, of course, that was because they had formerly been Methodist ministers. My brother Hal had asked me once if I had ever seen a Methodist minister's grave. I told him I never had. Hal said the reason was that Methodist ministers never die; they just turn into gray mules. Those gray mules in the barn lot were named Molly and Mary, and it seemed strange to me, for I had never known of a woman minister in the Methodist Church.

At times we had other animals, such as owls and raccoons. For a short while my family had a monkey, but that was much later. For several years, though, the most wonderful animals we owned were deer. To me they were wonderful because they were still wild. I seemed to have had an instinctive respect for wild creatures, which did not have to kowtow to mankind in order to live. I did not hold it against old Satin that she had given up her freedom in order to have a secure supply of food. I knew it really wasn't her fault. Her ancestors had simply been captured and enslaved. She had been born a slave. The way she would run to the far end of the pasture whenever I wanted to bridle her, however, showed me that she still had an instinctive memory of those days of freedom. She still had her self-respect. But wild animals were ones that had never been tamed by man. I don't know why I loved them for that. Perhaps I still had a streak of wildness in me.

Although the deer would eat the grain we gave them, they certainly wouldn't run up and gobble it down while we were there. They would wait until nobody was around, and maybe until the human stink had abated, before they would eat their

free meal. I almost felt ashamed every time I put out food for them.

My father built a high fence around an acre of land adjoining our house on the north side, and that became our deer yard. The first deer to go in there was a buck we called Billy. One of my cousins who lived near San Benito, South Texas, had roped Billy from his horse. He had crated him up and shipped him to me as a gift. Much of the far south part of Texas was then wild and undeveloped. Deer were plentiful down there. The "train excursions" of Yankees had not yet rolled into South Texas looking for investments.

Soon after Billy's arrival, my father acquired a beautiful little doe. When she arrived in a crate, she still had her spots. She eventually became the mother of three fawns.

Despite the presence of deer in the big yard, we also had a tennis court and some trapezes in that area. Traynham and I had even erected a canvas tent in the far northwest end among some mulberry trees. But as Billy grew older, and after he had scratched all the velvet off his antlers, he became very mean and wanted to assert his superiority over people. Eventually, he established complete control over his territory. We all learned to stay out of it for our own good.

One day Traynham, my younger sister, Queen, and I were playing in the tent. Suddenly Old Billy must have decided he had had enough of that ugly tent in his yard, for he charged it full force. He didn't knock it down, but several of the points on his antlers came through the canvas as he continued to ram and paw the tent. Traynham grabbed those points and held onto

them until Queen and I had escaped across the yard and out the gate. Then Traynham let go of the antlers and went out the front door of the tent. Old Billy was waiting for him as he came out. I had never known that Traynham could run so fast. He outran Billy and got through the gate just before Billy's antlers crashed into it. Billy then went back to the tent and finished it off. He knocked it down, twisted it up, and even got a small piece of the canvas hung onto his antlers.

We hated to give up that yard for playing, but I couldn't help being proud of old Billy.

* * *

Before we acquired the deer, and before my father had built the high wire fence for the deer yard, my brother Hal often played tennis with his friends in that area. Just beyond the

46

tennis court, over a picket fence, was a green turnip patch. One day when Hal and a friend were playing tennis, a tennis ball was hit wild, and it sailed out into the street. Hal saw my sister Esther near the tennis ball, so he shouted to her, "Esther, will you please throw that tennis ball back to us, like a good girl?"

Esther saw the ball and went and picked it up. But instead of throwing it back to Hal, she threw it as far as she could in the opposite direction. I think Esther also had a wild streak in her.

That made Hal mad. He still had one tennis ball in his hand and also his tennis racket. He took out after Esther, who was now fleeing to escape his wrath. When he caught up quite close to her, he raised his racket and served a hard serve. The ball hit Esther right in the back of her neck. I had run along with Hal to see how it was going to come out, so I was also close by when Esther, on being hit by the ball, began spitting a lot of little white things out of her mouth.

I said, "My God, Hal, you have knocked all her teeth out!"

I think Hal was really frightened. But, as it turned out, Esther was eating a raw turnip when the ball struck her. We were certainly relieved when we learned that it was the raw white turnip and not her teeth that had flown out of her mouth.

Some years later, Hal went to Vanderbilt University and became a dentist. I always suspected he got the idea of being a dentist when he thought he had knocked all of Esther's teeth out.

* * *

Esther usually put the food in the yard for the deer. She would always call them, but they would never come until after she had gone, although they seemed to stare at her kindly.

One day old Billy took out after his son, Jerry. Rather than be caught and possibly gored by Billy, Jerry ran and jumped clear over that high fence. It must have been all of sixteen feet high, but Jerry cleared it and kept going. I never saw that young buck alive again. Now and then, people would report seeing Jerry down in the Navasot River bottom. Jerry, always wild, was now in a wild environment. But unfortunately for him, my father was a deer hunter. Hunting deer was his favorite sport. One night my father took his rifle and a "hunting lantern"—a headlight that was worn on his hat and fueled by carbide gas—and went deer hunting in the Navasot River bottom. He brought Jerry home strapped to the fender of his car.

For some time afterward, my family had venison. But my sister Esther never ate one bite of that meat. She told me it would be not like just eating a person, but like eating a good friend.

48

CHAPTER IV

Girls

During my earliest conscious life, I made no meaningful distinction between boys and girls. Argoo was to me a person I played with: that was all. What I distinguished in those days was personality, which for me had nothing to do with gender.

Later on, there did emerge into my world a colorless division among people: those who were women and girls and those who were men and boys. It was a dry fact thrust upon me, irreversible and constant. Eventually, I learned that I was a member of that group that wore a dress on each leg, called britches.

And I then looked at all those who only wore one dress as belong-ing to the other group.

One day, however, when I was about eight years old, I observed something which I knew I could never have seen while looking at any member of my own group. I had gone with my mother and three of my sisters to take a swim in a beautiful pond that had been formed by a gas well which had turned to salt water. The pond was filled with clear salt water. My sisters had invited a little girl to go along with us for the swim. Her name was Roselle Smith, and she was about my own age. My sisters wore for swimming the ponderous bathing suits of those early days. I wore my underclothes, and I later learned that Roselle Smith had on her nightgown. But whatever it was she wore to swim, and of whatever material, when she raised up out of the water with that garment sticking tightly to her body, I knew I was seeing some kind of miracle. There had never been anything so wonderful in my life up to that point in time. I as-sumed that what I was seeing was the possession of that indi-vidual, only. I knew it could never exist in any member of my masculine group, and it never occurred to me that it could ever exist in any other member of the feminine group. My memory picked it up and stored it ever so carefully away, where I could ponder it at will.

Later, long before I had reached high school, a dark-haired girl whose name was Sally Dick Steen decided she was my spe-cial girl. When my class would walk together down the railroad track, she would always be walking with me. On every picnic it was the same. I had had nothing to do with that pairing. It had

been thrust upon me, and while I thought she was pretty, I knew she had made a very basic mistake. It may have taken over a year for that connection to dissolve. It did dissolve, however, and eventually she married a fellow student before either of them was old enough to be a husband or wife.

Several years passed before what I had seen when I looked at Roselle Smith revealed itself to me again. Then one day when I was in high school I was walking with my new friend Leon Black behind a group of girls. Suddenly I looked and saw again that amazing integration of rhythmic lines going along with one of the girls. I only knew her last name, which was Switzer, but there could be no mistake: she had what Roselle possessed. Again I was in a daze, but fortunately it lasted only a few seconds. My memory picked this experience up and stored it away, no doubt as carefully as the first one. Because of those two vivid events, I now knew that the feminine world was much more different from that of men and boys than I had believed possible.

* * *

Despite this new concept I had acquired, my interest in hunting, fishing, and camping kept me, for a time, from exploring further that fascinating world of girls. I knew there was something wonderful and mysterious in that feminine group of people. Roselle Smith and the Switzer girl had given me a glimpse of it.

When finally I reached the tenth grade, my friend Leon
Black had begun to neglect his camping, fishing, and hunting
duties very noticeably, and it was clear to me that girls were the
cause. He asked me to go on a hayride which he had got up, and
it was while sitting flat in a wagon bed, on a thin sprinkling of
hay next to a girl named Beth, that I became connected again.
This one was not like Sally Dick, who simply had acquired me.
This one started teaching me to sing songs with her. She knew
the words to many songs, such as these two:

> Around the corner
> Under the trees,
> The sergeant major
> Said to me:
> Oh, who would marry you,
> I would like to know?
> For every time I look at your face
> It makes me want to go
> Around the corner . . . (and on and on)

> I wear my pink pajamas in
> The summer, when it's hot.
> I wear my flanner nighties in
> The winter, when it's not.
> But sometimes in the springtime,
> And often in the fall,
> I jump into my little bed
> With nothing on at all.

Since Leon had begun to waste his time having dates with a girl named Mildred, I thought I might as well start having dates with Beth. She became my "steady," and she loved to pet. She even taught me the "butterfly kiss." This involved putting her face against my cheek and fluttering her eyelashes. Beth played the piano like a professional, despite her young age. I would often sit beside her on the piano bench, listening to her play and sing .

There came a time, however, when Leon said he was "breaking up" with Mildred. "It's all off," he announced. "I won't be dating her anymore." He stopped cold going with Mildred.

"All right," I said, "since you have stopped going with Mildred, the least I can do is stop going with Beth." And that is what I did. I just announced that I had to quit seeing her. That must have proven the superficiality of our relationship.

What a cruel thing to have done, as I recall it. At that time, though, it didn't seem cruel either to Beth or me. After all, I had not learned much more about the feminine group, and I certainly had not seen again that miraculous integration of rhythmic lines. I think Beth must have thought I had become as intangible as a dream.

Leon Black told me something then which was repeated to me years later, in different words, when I finally had decided I was going to marry the only girl in the world for me. Leon said, "We don't have anything to do with choosing a girl to marry. It will be done for us by some mysterious force." The other person said, years later, "As for choosing a girl to marry, we are all at the mercy of evolution."

CHAPTER V

High School

After my classmates and I had finished the seven grades at grammar school, we had to go to a different school building to begin high school in the eighth grade. By that time, the high school was situated on the south side of town, right across the street from my home, so there certainly could be no excuse for me ever to be tardy.

My grammar school was on the far north side of town, however, and during my first five years there the high school and the grammar school were in the same building. On some cold winter mornings, my sisters and my older brother were so

slow in getting ready for school that when we finally got started walking through our front door we knew we were almost certain to hear the "tardy bell" before we reached the school building. To be tardy, for some strange reason, was considered far more of a disgrace than to be absent. I can remember there were times when, as we approached the school late, we all listened eagerly to hear the tardy bell ring. And when it was ever so slow ringing, we would drag our heels to help it along. We learned that a tardy bell is as slow to ring when you listen for it as a water kettle is to boil when you watch it. When finally it would ring, we would all feel so sorry about being tardy that we would turn around and slowly, sheepishly head for home.

Those days finally passed. Now I had only to walk across the street to join members of my eighth-grade class. One of the first persons I met on that first day in high school was Leon Black. He was in a class above me, but Traynham Pitts, who was in Leon's class, brought us together. Almost immediately, Leon became closer to me than any member of my own class except for John Corley.

* * *

At the top of the stairway that led to the study hall on the second story of our high school, there was a tall pedestal. On that pedestal, in stark-white plaster, stood a copy of the "Winged Victory of Samothrace" in the round. Crowded among all the other pupils, I would go up and down the stairs several times a day to and from classes. To me that tall white statue was only a

fixture. I could easily walk past it without ever seeing it. But today I doubt if anyone knows more about the subtle shapes of the "Winged Victory of Samothrace" than I.

Leon Black used to love to sneak up beside a girl as we were walking up that crowded stairway. He had developed the skill of running his arm clear around her back in such a way that he could punch her and cause her to believe she had been punched by the person on the other side of her. As he punched that girl, Leon would look as innocent as a lamb. One day while we were going up the stairway, I happened to be walking alongside a big girl named Anna Mae Magnason. Leon was walking next to her on the other side. When I arrived next to that pedestal, Leon must have given Anna Mae a good strong jab in her side, for she turned to me with a frown on her face and gave me such a shove that I fell against the pedestal, causing the "Winged Victory of Samothrace" to come crashing down. It broke into a thousand white pieces, which were scattered all up and down the stairway.

That afternoon, to my horror, the study-hall teacher told me that I was to stay after school and report to the superintendent's office. I liked the superintendent. He was not my science teacher, but I did have him in science lab, although I never did feel that I knew what I was doing while working on the experiments he assigned. In the lab class at that time, John Corley and I were the only students.

When I reported after school to his office, the superintendent smiled kindly at me and said, "I understand you knocked

the statue off the pedestal and broke it. That was the 'Winged Victory of Samothrace,' you know."

"Yes, sir," I said. "I did it, all right, but I don't know exactly how it happened." I remember that I was thinking George Washington had been in a similar situation after he had chopped down a cherry tree. I felt that now was the time to be very honest.

"Well, it would cost too much for you to replace that statue, even if another one could be found. I suggest that you put it all back together again. I will provide you with the plaster of Paris and give you a good picture of the statue to refer to. You may work on it every day after school."

"Yes, sir," I said. "I'll do it if you say so." I had no idea how to put that thing together again.

A couple of days later, the superintendent presented me with a box of plaster of Paris and told me to mix only a little at a time because it got hard so fast. He also gave me a sepia picture of the statue, and I knew I was going to try. He presented me with a big sack of all the broken pieces that had been picked up after the crash, and told me that I would find a table set up in the lab, with the broken statue upon it. That was where I was going to do my sculpturing work.

I got a long metal fingernail file and some sandpaper and started on that job. Soon I discovered that if I had shaped a feather in the wing incorrectly, I could wait for the plaster to harden and then carefully sand the feather down until it looked right to me.

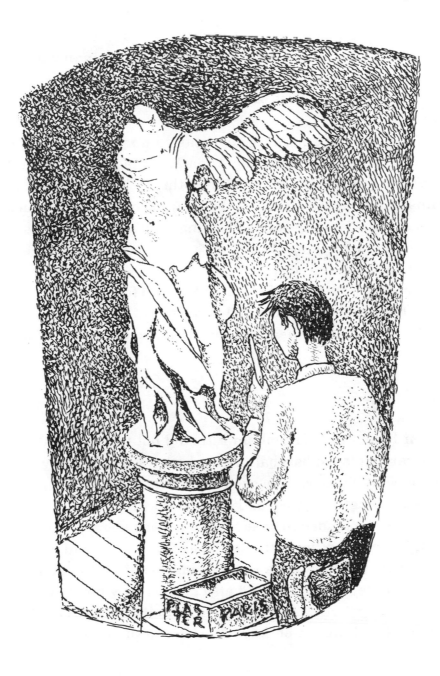

Every afternoon, I worked away on that woman with wings. It took me about two months to finish her. Then one day I carefully picked her up, took her to the hallway, and placed her on the pedestal.

The very next morning, as I started up that stairway, I found myself walking alongside Anna Mae Magnason. When I got up to the "Winged Victory of Samothrace," I turned and said to Anna Mae, "How do you like the statue now? I put her back together again." As she started looking at her, I said, "Anna Mae, there is something else I want to tell you; I am not the guy who punched you that day."

Anna Mae stood looking at the statue for some time. She seemed to be admiring the way I had fixed it. But I never did know for sure that she believed I was not the one who punched her.

* * *

At high school Traynham Pitts did not take part in sports, and he rarely played baseball with us after school. If a fly ball came his way, chances were good that, if he got to it, the ball would go through his glove and land on the end of his nose. That was because he tended to shake when he was about to catch the ball. But in many other activities he excelled. He could pick a horsefly from a mule with a rawhide blacksnake whip and never touch the mule's hide. He could also make that whip pop like a rifle shot. Traynham was a natural in handling horses and mules. He liked the out-of-doors much more than any classroom.

60

Once when I was in science class with him, Mr. Bruton, our science teacher, began asking questions to find out which students had studied the lesson. The question he asked Traynham Pitts surprised me because I had not seen anything on that subject in the science lesson.

Mr. Bruton pointed at Traynham and asked, "Mr. Pitts, can you define electricity?"

Traynham was doubly surprised, since he had slid down in his desk seat so he couldn't be noticed by the teacher. After pulling himself back into an upright position, he scratched his head and twisted around as though he were thinking hard.

"You know," he said, "I *did* know that, but I forgot."

"Well, well, Mr. Pitts," said our teacher, "what a pity, what a pity! Here in this class we have the only man in the world who ever knew what electricity was—and he forgot!"

Another time, he asked Traynham to give the definition of a "hole." He spelled the word, h-o-l-e, so Traynham would know he didn't mean the word "whole."

This time Traynham didn't look worried. He realized the teacher was asking about something that existed in his own world.

"A hole? A hole?" he repeated. "A hole is . . . nothing, with a ring around it!"

"Very good. Very good," said Mr. Bruton, "although one might wonder about the composition of that ring surrounding the nothingness."

One thing Traynham did not excel in was accuracy in shooting a gun, although at times I did have certain suspicions.

He missed clean when he shot at Roger, Miss Betty Johnson's little dog. On that occasion, he said someone shoved him. But his aim at ducks was equally inaccurate.

My father seemed to love Traynham's shooting. One day he and Traynham and I were returning from our ranch when we saw a flock of ducks on a pond down a hill from the road.

"Look at those ducks!" I shouted. "I can slip up behind that dam and get some of them!"

"No, no!" my father insisted. "Here, Traynham, take this gun and go after those ducks." I think my father thought I might accidentally hit one of the ducks, and he was certain they were in no danger at all if Traynham was doing the shooting.

Traynham took the shotgun and hurried down the hill. He then sneaked up behind the dam. My father was watching even more intently than I.

When suddenly the ducks flew up, Traynham started shooting. He shot five times with my father's automatic gun, but the ducks flew away, making a beautiful curve in the sky as they departed, unharmed. My father kept laughing until Traynham returned. I could never understand why he thought it was so funny when Traynham missed what he was shooting at. I suspected that Traynham just didn't like to kill any living thing. I began suspecting that when he missed Roger.

* * *

We all disliked old Ida. She was a big Jersey cow that belonged to the Corley family, and John was the member of that family whose job it was to milk her. He had to milk old Ida on time—not one minute early or one minute late. No matter where he was or what he was doing, when the time arrived for milking old Ida, John had to be at her side. John also happened to own the baseball and the bat we used for playing baseball. Each of us owned a glove, but nobody else seemed to own a bat or even a ball. We relied on John Corley for those two essentials. If the game was tied and the bases loaded at the time when John suddenly realized Ida was waiting to be milked, then the game was abruptly called. John had to leave and milk old Ida, and, of course, he had to take his bat and his baseball with him. We all knew old Ida couldn't care less about baseball. She was the original contented cow, and we thoroughly disliked her.

John was a good player, and also he had a bright, inventive mind. One day, when I was catching behind the bat and John was pitching, he suddenly began throwing such an amazing curve that not only could nobody hit it, but I couldn't even catch it. It went up and down and sideways. He fanned everybody out on the opposing team. Nobody had ever seen such pitching. When our side came to bat, we made a racetrack out of the ball diamond. We won by about sixteen to nothing.

It became obvious to me why no one could hit John's pitches. The minute I got that elusive ball into my hand, I discovered it was as light as a duck feather. John had two baseballs: one for his pitching and another one for the other team. Few people knew that. He cleverly kept it a secret. I knew it, of

course, and another person knew it, also: our friend John Quinn. It turned out he had a half-interest in that phony baseball. John Quinn's father was a leather-saddle maker, and he had made the baseball for the boys. He had cut the leather and sewn up a ball that was stuffed with cotton. It looked exactly like a real baseball, but when it was thrown it made all sorts of didoes. Nobody could hit it.

I felt sure John Corley would soon be in the big leagues if only he could keep his ball a secret. But for some reason I never understood, he and John Quinn had a falling out. One day John Quinn took a sharp knife and cut that ball exactly in half. He gave John Corley his half. Their partnership was dissolved, and John Corley's pitching ability went into a terrible and permanent slump. Nothing is as useless as a baseball cut in half.

* * *

Leon Black, John Corley, and I did not become members of the Mexia High School Debating Society by choice. We were in it because our history teacher, Miss Lil Harper, put us in it. She said, "From now on you will stay for the Debating Society meeting every Friday after school. Occasionally you will be assigned a topic, at least a week in advance, which will give you plenty of time to prepare for it."

That was an extra burden we hadn't counted on. In fact it was a calamity. We knew we were stuck. Miss Lil Harper might even flunk us if we didn't show up. John Corley said, "You never can tell about women."

It had been our custom to leave immediately after school almost every Friday. We would hitch old Satin to my father's hack and head either for the Navasot River bottom, down below the Focke farm, or for the Reunion Grounds. It was important to arrive at those places before dark. We would camp under the tall trees in the river bottom or under the wide oak trees at the Reunion Grounds. And we would stay until Sunday. To drive to either place took almost three hours.

There were several old wooden buildings at the Reunion Grounds, such as the Dance Pavilion—open on all sides—and the Old Confederate Soldiers' Headquarters. But not a soul was in those buildings except during the annual celebration which lasted only about a week. The rest of the year the grounds and the buildings were completely abandoned, and soon after the celebration the forest would begin to dominate. Persimmon sprouts and sumac would begin growing up around the buildings. Grass would get high and the buildings would begin to blend into the surrounding woods. If it hadn't been that way, we would not have camped there. Those buildings became completely inoffensive. Some years later, however, after natural gas was discovered only a few miles away, a rich man decided to make a gift to our town. He had cement tables and cement benches built among the trees. That ruined the place for us, just as it must have made it attractive for the other kind of people. All those cement benches and tables scattered among the old gray buildings and trees violated the place. Leon Black said they were uncouth. He loved to use big words.

Bad as the benches and tables were, however, they were nothing compared to the so-called improvements that appeared years later when that area was made into a fine place for the public. The Reunion Grounds then had a big iron gate as an entrance. You even had to pay to enter. Of course by that time we had taken the place off our list. I suppose it had taken us off its list as well.

To get to the river bottom, we had to drive over a deep sandy road to the Focke farm. Once there, we would open the gate and drive right alongside Mrs. Focke's house and on down to her big barnyard. Often we would find Mrs. Focke down there. She was usually surrounded by geese, their heads held high as though they were begging to be fed. Mrs. Focke was quite old, and she always had what appeared to be a lot of gray shawls wrapped around her. The barnyard itself was colorless, but even so, she stood out against it as a dark-gray, angular shape.

I felt secure driving through her barn lot, because I knew she knew me. She was a friend of my father, who was a close friend of her son. Her son was almost as old as my father, and they often went hunting together. Mrs. Focke also had two friendly daughters, both old maids—Miss Anna and Miss Tina. I rarely saw either of them outside. They must have done all the housework. But old Mrs. Focke worked outside all the time. My father said she could do as much work as a man.

I would greet her as we drove through the barnyard and tell her we were going down to the river bottom to camp. She would wave a hand outside all those shawls she was wearing, and we would drive through the second gate, close it carefully, and continue on down through the old fields to our campsite, just inside the edge of the deep forest.

That is the way it always had been when we were going to camp in the Navasot bottom. But now it was a Friday. Not only were we stuck with the Debating Society, but Leon was on the program. We were almost sure to get a late start. Leon was to debate some other guy on the subject of Single Tax. He was to take the affirmative, whether he believed in it or not. Miss Lil had said, "This is a debate. The one who makes the most points wins. The judges will decide."

That afternoon after school, all the members of the Debating Society were assembled in the study hall. The negative side was to speak first. He was a great big boy, as big as a grown man. His father was a blacksmith. This boy's name was Wilford Oliphant, but we all called him Wilofud Olofud.

Wilofud got up and walked to the front of the stage. We were hoping he would make it short, for we were anxious to get started for the woods. He began talking about why we shouldn't have single tax. He seemed to love to talk to an audience. We didn't listen to what he was saying, because we were so nervous about the time he was taking. We really wanted him to get it over with, but he kept on and on. We wished we could have thrown a rock at him for being so long-winded.

Finally, he stopped talking and went back to his seat at the rear of the stage. It was getting later and later, and we didn't want to arrive at our camp in the dark.

Now it was Leon's time. I felt sorry for him because I knew he had not made any preparations for the debate. He was also as anxious as we were to get going to camp. He was now about to be standing up there with all those kids looking at him. He would be wanting to get away, and I felt sure he didn't know a thing about the debate. I really was feeling sorry for him.

The moderator got up and said, "We shall now hear the affirmative side, which will be presented by Mr. Leon Springfield Black."

Leon got right up from his seat and stepped forward. He looked so confident that I wondered if he really did know what single tax meant. I thought maybe he had decided there was no way for us to leave early, so he might as well do the best he could, regardless of the time it might take and even though he would have to pretend he knew what he was talking about.

Leon walked to the front of the stage. He looked at the audience and said, "Ladies and gentlemen!" Then he turned

toward the back of the stage and said, "Honorable and distin-guished judges!"

I thought, "So far, so good."

Then he began speaking. "I have listened with great atten-tion to my opponent," he said, "and he has convinced me that nothing could be worse than single tax. I agree with him com-pletely, and therefore there is no need for me to debate. Thank you very much."

He then jumped down from the stage. John Corley and I joined him, and we left the Debating Society before the audience had begun to stir.

As we raced toward the barn lot to get old Satin and hitch her to the hack, I said to Leon, "I hate to say this, but you are going to hear from Miss Lil when we get back. I hope you figure out what you are going to tell her."

* * *

Old Useless, the dog that had been my companion for about eight years, still went everywhere we went. After we left the debate that Friday, he followed us all the way to the Focke farm. Now that I recall those early days, I wonder why we never thought to pick him up and give him a ride in the hack. He al-ways walked. When the weather was hot, he would walk in the shade under the hack between the wheels. He would keep his gait the same as that of the horse. Perhaps it was all that walk-ing that made him grow to be so strong.

Old Useless could lick any of the dogs that ran out from the farmhouses we passed along the way. Those dogs would rush out, cussing and growling as though they were going to eat him alive, but they soon learned better. Useless was not only strong, he was also smart. He would always mount his adversary from behind, holding on with his two front feet and biting his opponent in the back. He knew where the danger was: up front where the teeth were. By holding on in that rear position, he could gnaw at will on the other dog's back while the other dog's teeth could not get near him. Eventually his enemy would let it be known that he admitted defeat, that he had had enough. Useless would then release his hold and let him retreat. One time a dog tried to pull a fast one on Old Useless. After admitting defeat and asking for mercy, and being freed from Useless's grasp behind, the other dog started fighting all over again. But this time Useless immediately got his rear position back again. He did not let loose until the dog was thoroughly convinced he had made a mistake. On our return trips by those farmhouses, those same dogs would run out, barking. As soon as they saw it was Useless again, they would cease barking and retreat to their own territory.

Now, as usual, we drove through Mrs. Focke's barnyard and on down to our campsite, only this time it was dark. That Debating Society had not only made us late, it had also caused all three of us to worry. We were worried mostly about what would happen to Leon because of the way he had cut short that debate on single tax.

John said, "Leon, did you know anything at all about single tax? What does it mean, anyway?"

"Damn if I know," Leon answered. "I only wanted to get out of there."

"You did it, all right," I assured him, "but all three of us may have to join the Navy when we get back home. I've heard anybody can join the Navy after he's thirteen years old."

As we approached our camping place, we had the good luck to see the moon coming up in a clear sky. Because of that moonlight we had no trouble getting our tent up, even though we were surrounded by a thick grove of tall young trees, or saplings. They all rose straight up like poles.

From our tent the land sloped gently downward to a little dry creek bed. At that place the ground turned steeply upward. On the far side of the little creek the trees were much larger, and the brush between the trees was so thick all one could see there was darkness.

After we had built a small fire in front of the tent and had cooked some long homemade sausage on green sticks held over the fire, Old Useless started barking furiously at something on the other side of the creek. We tried to stop him, but he insisted on barking as though he hated and feared whatever it was he

was barking at. He would run down the slope, barking and look-ing up slightly as if something much taller than he stood close to him. Then suddenly he would retreat as though something he feared was chasing him. After he would get back to where we were, he would turn around and again rush down the slope, barking furiously at whatever it was.

This barking went on for about fifteen minutes until we began to feel a little bit frightened. We never did see anything, but apparently Useless saw it. And what he saw he didn't like at all. Leon said that Useless was seeing a ghost. We knew that over in that direction in the woods there was an old abandoned cemetery. None of us mentioned it, but we all knew it was there. After we went to bed in our tent, Old Useless, who slept at the entrance, would growl at intervals all during the night.

We were glad when daylight finally came, but we never did know what Useless was so mad at that night. As smart as he was, he couldn't let us know what it was.

After breakfast John Corley, to our surprise, pulled out a pipe, loaded it with tobacco, and started smoking it. None of us had ever smoked before. I began to think about Miss Betty Burson.

"John," I said, "wasn't Miss Betty Burson your first-grade teacher?"

"Sure she was," John answered. "I remember her well. Why?"

"Well," I said, "didn't she make you promise you would never smoke a cigarette until you reached twenty-one?"

"Sure she did," John said. "That's why I'm smoking this pipe. I promised her I wouldn't smoke cigarettes."

"There's not much difference," I said. I didn't mention John's smoking again, and John kept on puffing as though he was enjoying something Leon and I didn't know about.

We sat around doing nothing that whole morning, while John kept on smoking his pipe. Of course we started talking about Miss Lil Harper, our history teacher, who had put us in the Debating Society.

"I like that woman, all right," Leon said, "but I guess she is not gonna like me, if she ever did."

"I don't think she dislikes any of us," John said, "but she certainly does not like Traynham Pitts.'

I said I didn't know that anybody disliked Traynham Pitts.

"Well," John said, "you are not in that ancient-history class that Traynham and I are in."

"Why doesn't she like Traynham Pitts?" I asked.

"Maybe she shouldn't dislike him," John said, "but when Traynham was asked about King Darius, he said, 'Old King Dairy Ass did this, that, and the other.' Every time he had to use his name, he would call him King Dairy Ass. Miss Lil was furious."

A little later, Leon and I were getting out our guns and shells in order to see if we could shoot some quail, when we suddenly heard John making an awful noise. He was leaning over with both arms against a tree, and he was making awful groaning sounds.

"My Godamighty!" I said to Leon. "What's the matter with John?"

We put our guns down and went over to see what was wrong with him. We found that he was gagging and heaving, and that he looked very white.

Finally he turned to us and said in a pained way, "It's that damn pipe. It's got me." Then he turned back toward the tree trunk he was leaning against and began to vomit.

After John got that over with, he seemed a little better, but he groaned and said, "Get me my gun!"

"Your gun!" I shouted. "Just what do you want with your gun? You are not *that* sick!"

John started retching again. "Yes, I am," he groaned. "Get me my gun!'

I couldn't believe my ears. I just couldn't believe a person could be so sick he would want to commit suicide.

Leon now came over to where John was retching and told him he would be all right in a few minutes, that he was only temporarily sick from the tobacco.

John groaned again and said, "I want my gun. I feel a lot better already. I'll get it myself."

Before we could stop him, he rushed into the tent. He came out immediately, and we saw that he had his pipe stuck into the end of his shotgun.

"I'm gonna get rid of this damn thing!" he cried. And with those words echoing off the surrounding trees, he raised his gun and fired.

That was the end of John's pipe, and that was also the end of his smoking. I never, ever, saw him smoke a cigarette, a pipe, or a cigar after that.

* * *

John Corley must have been very good-looking in those days, for all the girls seemed to like him. He was stronger than either Leon or myself. Because of his unusual strength he bought a second-hand motorcycle, which my oldest brother, Ben, helped him repair. A motorcycle was too heavy for me to handle. My brother had an extra one, called a Yale, which was less heavy, so he encouraged me to ride it. But every time I stopped I had to let it fall to the ground. It was just too heavy for me. John now had a Harley-Davidson. He had complete control over it. He even took a long trip on it with my brother—a several-day trip to West Texas and back. I could never have done that.

Living in Mexia at that time was an unusually beautiful blonde girl about our age. But as pretty as she was, she was so delicate her doctor made her go to bed and stay there. She must have been anemic.

John learned it was essential that this girl gain weight. He would go to see her and sit at her bedside. They definitely became sweethearts. Then John got an idea how he could cause her to gain weight and get so well she would not have to stay in bed. About every three hours during the day, he would tear out on his motorcycle to see her, and he would carry along in a car-

ton a big malted milk shake, sometimes with a raw egg mixed in it. She would drink all those malted milk shakes.

It wasn't long before John's anemic girl friend started gaining weight. I had felt sure she would, because I used to fatten my hog the same way. I would pen the hog up so he couldn't get any exercise, and I would pour the feed to him. The hog would finally get so fat he couldn't even walk. Lying down, he would just stick his head into the food trough and eat and eat.

As John kept pouring the malted milk shakes into his sweetheart, she got fatter and fatter. But after she had been living on those malted milk shakes for several months, John must have taken a hard look at her. Some of us suspected he had made her much too fat, and that was why he broke off relations with her.

A short time later, I noticed he had begun going steady with my former girl friend. It gave me a funny feeling to realize my old friend John Corley was now going steady with my former girl friend Beth. I tried to think he was doing me another favor, but I certainly hoped he would not start feeding Beth malted milk shakes. I still liked her that much.

For the first time, I now became aware of the image of another girl, a girl with jet-black hair. That image seemed to be lurking in one of those rooms of my memory that had not yet been used. There must have been a sign on the door of that room: "RESERVED FOR GIRL-EVENTS TO BE REMEMBERED LATER."

* * *

High school could not go on forever. The time arrived
when we would be graduated. That would mark the end of all
those public-school years, and I did not know what would follow.
John knew, because his father had told him he would have to
work a year in the furniture store before going to college.
Traynham Pitts had already left school. He quit before graduat-
ing. Someone said Traynham had gone to Houston and joined the
Merchant Marine. Leon Black, also a year ahead of John and me
in school, had now been at Texas A&M a whole year.

That summer after graduation, we couldn't look forward to
school starting again, at least not the high school we had known
so long. So John's father, who was the mayor of our town, gave
us a job. I think he let me in on it because he knew I could drive
my father's old Ford runabout. We would have to do a lot of
driving for that job.

Mr. Corley said, "You boys can use my desk here at the
store every night to fill in all the names on the forms." The job he
had given us was to take the school census in our school district.
We were to go to every house in the district and get the names of
every child of school age living in those houses.

I did not like the idea of working at Mr. Corley's desk at
night in that lonely furniture store. On the third floor, just above
the place where the desk was located, were all the coffins. Mr.
Corley sold coffins as well as furniture. I knew that very well
because John had a bridge table up among all those coffins. That
was where he made his friends go to play poker on some Sunday
afternoons when the store was closed. John knew he would win
our money in that place. He was used to those coffins, and the

rest of us were not. He could concentrate better among the coffins than we could.

It took John and me nearly two months to get all the names for the school census. About the time we finished our job, our friend Leon Black showed up from Texas A&M. He was late getting away because he had been making up a course he had flunked in college.

Leon now said to me, "I hope you have everything ready to go to A&M with me. I know our captain. We will be in Company G. I have already told him you are to room with me in Goodwin Hall."

That settled it. I had considered going to the University of Virginia, only because I knew my family had come to Texas from Virginia way back in 1850. But now I knew I would go to A&M.

CHAPTER VI

Aggieland

After I arrived at College Station, it did not take me long
to learn that Texas A&M was by far and wide the best school in
the United States, and that Texas University, because all the
students there were idiots, was the worst. All the A&M students
I met through Leon assured me of that. Another thing I learned
was that I was supposed to start yelling. I was supposed to yell
on the spur of the moment. Yelling would cause the A&M spirit
to grow much faster within me. The students would even get
together and practice yelling. There were "yell nights" when we

all yelled together, and we had a yell leader. But to yell was the thing to do at any time.

I found that once all the registration fees had been paid at A&M, there was no need thereafter for anything but pocket money. Every essential for the school year was covered on the day of registration. So when I went to the school store to get my uniform, I found that I owed nothing. My pants, my coat, my shoes, my leggings, even my army overcoat had been paid for at the registration desk. Because of that, I could see no reason why all the students should be calling the store manager "Mr. Cheat'em." But that is what they called him. I knew his name was not Cheat'em the moment I saw him. I knew that because I had a friend in my hometown who looked exactly like him, and my friend's name was T. B. Chatham. Later I learned that my friend was Mr. Cheat'em's brother, and that Mr. Chatham was the correct name for them both.

Soon I discovered that several other people seen around the college had been renamed by the students. For instance, there was a regular-army sergeant on campus whom the students called Sergeant Satchel-Ass. Another regular-army sergeant was called Sergeant Bristle-Bean. His hair was cut in such a way that each hair seemed to stand on end.

Besides my uniform, I had also received a heavy rifle. But of all my A&M equipment, my leggings gave me the most trouble. Each legging was no more than a three-inch-wide strip of khaki-colored wool cloth which, if dropped accidentally, would unroll and travel beyond the length of my room, through the door, and down the hallway outside. These strips had to be

wound around each leg, beginning at the shoe top and continuing round and round until the leg had been covered all the way to the knee. I soon found it necessary to get up at least fifteen minutes before reveille to get my leggings on in time to fall in line each morning with my company. On one occasion, while marching with my company to the mess hall for breakfast, one of my leggings came loose at the top. It began to unwind until it not only tripped me and caused me to stumble, but it also got entangled with a cadet two squads behind me. I am sure I got out of that without demerits only because I was a very new freshman, or "fish."

I was now rooming on the fourth floor of Goodwin Hall, and my roommate, my boyhood friend Leon Black, had by this time achieved a social standing so far above my own that I was in awe of him for the first time in my life. He was now that exalted individual before whom all freshmen trembled: a sophomore. And I, a lowly freshman, was rooming with him. Whatever social life I might have during the coming year would not involve him. We were to live on two different social planes.

Fortunately the room next to ours was inhabited by two freshmen: Robert E. Kellner, from Mississippi, and his roommate, Fatty Carroll. My vicarious introduction to the A&M tradition of hazing happened one day when I heard outside their room a loud command: "Fish Kellner! Report immediately!" I peeped out my door and saw a tall, thin young man step into the hallway from his room and stand before a fierce sophomore who held in his hands a one-inch-thick board about three feet long with a handle at one end.

"Pootch, fish!" was the next command, and I saw Mr. Kellner bend over in a dignified manner, and position his rear end at the mercy of the sophomore with the heavy board. What followed were four or five hard blows which landed squarely on Mr. Kellner's gluteus maximus. With no further words spoken, the sophomore retreated down the hallway, while Fish Kellner straightened up and marched with the same dignity back into his room.

Realizing now that I was also a fish and equally vulnerable, I went immediately to Fish Kellner's room to get all the information and advice he might offer me regarding freshman etiquette.

After introducing myself, I said, "I saw what happened in the hallway. Does it happen often? And did it hurt?"

"It happens any time," he answered, "and it doesn't hurt if you know how to 'pootch.' My roommate, Fatty Carroll, hasn't learned how to pootch yet, and his ass is always black and blue."

While I was watching Kellner receive those heavy blows from the sophomore, it amused me to see how much bigger he was than his assailant. It seemed obvious to me that Kellner could easily have taken the board away from the sophomore and paddled him instead.

I said to Kellner, "That was a mighty little fellow landing those blows on you. You could have handled him with ease."

"Yes," he answered, "but you don't do that. When you are a freshman here, it would be a disgrace to turn on a sophomore. Even the freshmen would disown you."

I knew very well that I would abide by that rule, regardless of the beatings I was sure to receive. But it occurred to me that an older person, set in his ways, had better not register as a freshman at A&M. If his attitudes were those of an adult, if he had put away his childish ways forever, he would surely be in for deep trouble.

Kellner had told me he was from Fernwood, Mississippi, so I said to him, "Mississippi, if that is the case, if we are going to be beat up regularly, then I think we ought to do something to deserve the beatings." And from that moment he and I never ceased to think·up schemes against the sophomores.

While I was in Kellner's room, Fatty Carroll, his roommate, came in. After introducing us, Kellner said to Fatty, "Show Jackson your ass, so he'll know how important it is to learn to pootch well."

Fatty didn't hesitate. He pulled down his pants and showed me his rear end. I saw that around the deep-bluish-purple part, his skin was as white as snow. "I'm learning," Fatty said, "but I can't seem to tighten up the way Bob can."

Right then I learned that by contracting the gluteus maximus muscles it is possible to make them so hard a board will bounce off and not do any damage. It didn't take me long to learn how to do it. While I realized such knowledge would be of little value after I left A&M, I knew that while I was a freshman, it was as important as anything I might learn in the classroom.

Hardly a day passed after that when some sophomore did not order me to pootch. They would often say, "This is going to hurt me more than it will hurt you. But you have to learn you

84

are an Aggie now, and this is what will keep you from forgetting it." I was now able to make my rear end like a rock, so I never got bruised even at those rare times when I was knocked down by the blow.

On Sunday mornings we were permitted to sleep an hour later, but when we did get up we had to march to chapel. The chapel was in the opposite direction from the mess hall, but on the same wide street called Military Walk. One Friday, Mississippi came to my room with an idea. Fortunately Leon Black was not present. In fact I seldom saw him. Even at night he would come in so late I would usually be sound asleep. Mississippi now had a good idea.

"Sergeant Atkinson will be gone for a week," he said. "Somebody in his family is real sick, so he won't be back for a week." I was wondering if this Sergeant Atkinson could be kin to old Jack Atkinson, the drunk in my hometown.

Mississippi went on with his idea: "Meet me in the hall Saturday night, after midnight, in your bare feet. We'll collect all the shoes. Sergeant Atkinson has left his transom open."

I knew at once what he meant, but I wondered if we could do it. After all, part of our company was quartered in the basement of that building, while the rest of us were on the fourth floor.

When Saturday night arrived, I was so excited I don't believe I went to sleep before we met in the hall. We knew that no one ever locked his door in that building, and some doors were not even closed. Mississippi and I got right to work. We worked furiously. We would sneak into the rooms and collect the

shoes until we had all we could carry. Then we would go and toss them through the transom of Sergeant Atkinson's room. We had to use the transom because when the sergeant knew he would be gone a week he locked his door. I think we managed to collect at least eighty percent of the shoes of the company. After we had dropped them through the transom, we brought our own shoes and tossed them through, also, to cover our tracks. Then we went to our rooms and slept soundly. We knew we could sleep as late as we wanted.

Everything went as planned. Everybody missed chapel. There was a lot of yelling that morning. Some of the cadets even missed the late Sunday-morning breakfast. We never knew how anyone could be so smart as to find what room the shoes were in, but eventually someone with a master key unlocked Sergeant Atkinson's door. Mississippi and I stood in awe before the mountain of shoes we saw in there. Fortunately our own shoes were way off to one side of the pile where we could find them easily. The rest of the cadets had a hard time finding their own shoes. Those shoes were badly mixed up.

Mississippi and I thought we had a clean victory over the sophomores, but late that afternoon the sophomores lined up every freshman in Company G. They gave every one of us a sound beating in order to make sure they got the guilty one.

* * *

The "A" and the "M" in Texas A&M stand for Agricultural and Mechanical. Many of the students there were studying agriculture, and Mississippi was one of them. Mississippi told me his grandfather was a landscape architect who had laid out all the planting on the A&M campus. When I was there it all seemed to be oak trees, and they were quite small.

I had decided to study chemical engineering. I think that was because I had turned over a five-gallon bottle of hydrochloric acid in the high-school lab and had thought to pour a bottle of what was called a "base" on it. The base neutralized the acid and stopped all the smoking immediately. At the time, I was all alone in the lab. I was supposed to be working on the "Victory of Samothrace," and I don't remember how I happened to knock that bottle of acid over. But I was impressed by the way one chemical had such an immediate effect upon the other. I think that is the reason I decided to be a chemical engineer when I arrived at A&M and had to make up my mind.

So I was now registered as a chemical engineer, even though the engineering students all took the same courses the first year, regardless of whether they were to be civil engineers, mechanical engineers, chemical engineers, or architectural engineers. Apparently the agriculture students never took any of the engineering courses, for I never saw Mississippi in any of my classes.

Leon Black, my sophomore roommate, had to repeat every course he had taken the first year. That was because he had flunked them all. I learned that he would not have been permitted to return if his first year had not been in so much turmoil

because of all the deaths on campus. That was the year of the great 1918 influenza epidemic, and the students on campus that year died like flies. Leon was lucky to have come through even with his life. It was understandable that he did not survive the courses he took.

Actually, something had come over Leon that year. He had changed from the boy I had known in high school and had gone camping and hunting with so often down on the Navasot. We had hunted so much together that we knew just which side to shoot when the ducks or quail flew up. Now Leon was different. He told me the most important reason for going to college was to make good connections. He wanted to be known on campus as a "character," and it seemed to me he was on his way toward flunking again all those courses he was taking over. Perhaps I should add here, however, that years later Leon was the only one of all my A&M acquaintances who became a multimillionaire.

In those days at A&M, the constant hazing of the freshmen did not help them at all to make good grades. Luckily I found much of what I was studying to be little more than a review of what I had had in my senior year at high school.

One day I was going through my trunk to find some fresh underclothes when I discovered six or eight documents I had thrown in with my other things. Leon asked, "What are those important-looking papers?" He just happened to be in our room at that time.

I handed them to him. It turned out they were scholarships that had been presented to me when I graduated from high

school. Leon, looking them over, found that one of them was to A&M.

"Come with me!" he said. And with the document in his hand he led me straight to the registrar's office, where he presented the paper through a window.

"Is this thing any good?" he asked the clerk. She looked at it and said, "Of course! It's worth twenty-five dollars." Leon and I went immediately to the shop where soft drinks were sold. We each ordered a big thick chocolate malted milk. Were they good! We went back to that place almost every day and got ourselves those thick malteds until we had used up all that money. Those malted milks were probably the kind that made John Corley's girl friend so fat.

Leon was brilliant, even though he couldn't find much time to study, and he loved pretty girls. He really loved them all, and was a great "necker" with them. As a result he carried on a wide correspondence. He wrote love letters to them all. I was supposed to get stamps for his letters and mail them.

One day he handed me several letters. One was addressed to Mildred, one to my cousin Argoo—the same Argoo I played with when a small child—and one to Marie. I happened to notice that he hadn't sealed the envelopes, so I just switched the letters into different envelopes and mailed them. I didn't even read them.

After that, Leon's mail dropped off drastically. He couldn't figure out why his girl friends were neglecting him until finally he got a letter from Marie telling him what a two-timing dog she realized he was. Leon knew what had happened: the letters had

got into the wrong envelopes. But he assumed that he had been the careless one. I certainly never told him I had had a hand in it. I considered it just another lick Mississippi and I had given to the sophomores. Of course I did tell Mississippi about my success.

Leon had become such a character that he knew everybody on campus. He was talking to Buck Schiwetz one day. Buck was an architecture student, and at that time he was also the art editor of the A&M annual, which in those early years was called *The Longhorn*. Leon said to Buck, "I am rooming with an artist. My roommate is a freshman, but he did all the drawings for our high school annual."

That is how I came to meet Buck Schiwetz. He was so nice to me I might have thought he was a freshman. Actually, he was then a junior. Buck got me to make one or two drawings for *The Longhorn*. He probably had an influence on me because to help me with the drawings I was to make, he gave me a book full of examples of illustrations. For a long time thereafter I looked at the pictures in that book. I remember one, especially. It showed a girl, front view, holding a broken vase in her hand. The caption beneath the picture said, "'I have broken it!' she wailed." She looked very sad. That picture was very touching. I think Buck and that picture reawakened my interest in drawing.

* * *

90

Leon Black often said the only things wrong with A&M, the only things that kept the place from being Heaven on Earth, were the classes and the drilling. Of course he also said it would help a lot if that girls' school up at Denton, Texas, were moved down to A&M. It is true that we spent much of our time on the drill field, learning to do squads right, squads left, and right front into line. Leon used to sing a song about that:

> Oh, the sergeant, the sergeant,
> He's the worst of all;
> He gets us up in the morning
> Before the bugle call.

> Squads left, squads right,
> Right front into line;
> And then the dirty S.O.B.,
> He gives us double time.

We did have one sergeant, however, about whom no one could complain. He was a student sergeant, not a regular-army one, and his name was Alexander. After he was in charge of drilling just once, we started calling him Alexander the Great. But I noticed that he was given charge of drilling only one day.

One afternoon we learned that our captain was away and that Sergeant Alexander would be our drill instructor. The next morning our company was all lined up in front of Goodwin Hall ready to be marched out onto the drill field when Sergeant

Alexander called us to attention. He said in a loud voice, "Company G, attenshun!" Then he began giving instructions.

"At ease!" he commanded. "Gentlemen," he continued, "today we will have finger drill and exercise. As you may have noticed, our fingers have been sadly neglected this semester. Only through strenuous exercise of the fingers can we hope to develop them into the strong and freely functioning instruments they should be. Too much attention has been given to our legs and shoulders. Our fingers are lagging far behind our legs in development. This morning we shall begin to correct that." Then, in a commanding voice, he ordered us to attention again. The next order was, "Company G, be seated!"

We all then sat on the curb of Military Walk or flat on the street pavement facing Sergeant Alexander, and he began drilling our fingers. He kept us wiggling our fingers, one after the other, for nearly two hours. Of course he did give us five-minute rests now and then. When he finally dismissed the company, we knew he was the greatest student sergeant Texas A&M had ever produced.

As for the classes at A&M, my favorites that year were my mathematics courses, advanced algebra and analytical geometry. I also liked freshman English, which was easy for me. I could not understand how Leon Black had succeeded in flunking that course, for he was very good in grammar and in writing. He had had so much practice writing to his girl friends. I suspected that he flunked simply because he could never find time to attend classes. It certainly was not because he lacked ability. He wrote some themes for Mississippi, and Mississippi received A's on

92

them. I think Leon really did believe a great mistake had been made when courses of study had been introduced at that military college.

* * *

One of the things that intrigued me during my first year at A&M was the concept of infinity, which I met head-on in one of my math classes. What struck me forcefully was the fact that a way had been found to "use" infinity. That strange idea had always been real to me. All I had to do was look at the sky on a clear day and imagine going out into its space. It then appeared quite obvious to me that the space kept on going, on and on without end—no stopping, just continuing on forever and ever. I knew that was a far distance, indeed, but, as remote as it was from where I resided, I did not doubt its authenticity. I was glad there was a word for it: infinity.

I was slightly disappointed when I learned in my math class that a rising curve which kept getting closer and closer to a vertical coordinate line, until it was infinitely close, was never able to reach that line. But when its closeness turned out to be close enough for all practical purposes, I was delighted. What intrigued me equally was that the concept of infinity applied not only to space but also to time. I knew that I was, at that period of my life, nineteen years old, and I suddenly realized there was an infinite length of time extending behind me and an equally limitless amount of potential time out in front of me into the future. That thought suddenly made me feel that I was living on

the point of a needle, and I could not help wondering how all the world I was seeing around me could also be on that same needle point with me.

After entertaining a few thoughts of that sort, I began to see trees, buildings, people, dogs, cats, and everything else in a different way. Everything was now in a different world from the one I had been living in before I came to A&M.

One afternoon, while Mississippi and I were walking down the street where the professors lived, I said to him, "Mississippi, did you realize that you and I are walking on the point of a needle, and that billions of miles and billions of hours and days stretch out in all directions from where we are?"

Mississippi looked at me as though he thought I had gone off my rocker. "What's that got to do with us?" he asked.

* * *

The days kept rolling along as we continued to live so actively on the point of that needle. The entire company continued to go at regular intervals onto the drill field where we all marched with our guns on our shoulders. On certain nights we would go out and yell together, and we would go to our classes on scheduled hours and days. I often thought how strangely elastic was that needle point in time on which we all did so many things. Fall had changed into winter, and winter into spring. All those oak trees Mississippi's grandfather had planted around the campus did not seem to change. They were live oaks, and they

just kept on working the year round, apparently never shedding their leaves.

One day Mississippi came to my room and informed me he had received an order to report to the firing range for target practice on a certain day and at a certain hour. I told him I had just received a similar order. It turned out that we were to report for target practice at the same time. When Leon Black learned of this coincidence, he said we were extremely lucky.

"When you arrive on the target range," he said, "be sure to choose the same target number if you can. If you both can get the same number, you are in business." He went on to explain: "Whenever Mississippi shoots at the target, you will be in the pit pulling the targets. You must put up the bull's-eye flag every time Mississippi shoots, regardless of where his bullet landed, and he will do the same for you." Leon also said if we didn't do that we would have to go back and back to the target range until we qualified.

So that was the way it happened. The old regular-army sergeant assigned the same target to Mississippi and me, and of course we both qualified with amazingly accurate shooting records. We were both sharpshooters now, whether we believed it or not. Then we went back and took up our usual schedule on campus.

Shortly thereafter, Mississippi invited me to attend one of his classes. "It's a class in Shakespeare," he said. "I think you will be amused by my old long-haired prof." It seemed interesting to me that those students of agriculture, who wanted to be farmers, had to study Shakespeare.

One morning when I had no class at that hour, I joined Mississippi and went with him to his Shakespeare class. As we all assembled, I took a seat next to Mississippi near the rear of the room. I felt a little uneasy because I knew I didn't belong there. The old prof really did have long hair, and his civilian clothes looked as though they had never been pressed. As he talked about Hamlet, he kept looking at me. I now felt very uneasy for fear he might ask me a question about the lesson on Hamlet. But nothing happened. The hour went by while the old prof kept talking steadily about Hamlet. I had never read that play, so I didn't understand what he was saying; besides, I was too nervous to concentrate. I was relieved when the class was over and we all scrambled out of the room. I got the impression that Mississippi and all those other farmers didn't understand any more about Hamlet than I did. But I did decide that when I could get around to it, I was going to go to the library and read that play.

* * *

As the school year drew to a close, I knew I had acquired, in Mississippi, another friend, a friend in the same category as that to which John Corley, Traynham Pitts, and Leon Black belonged. Of all the people I saw each day, and of all those I had met in the past, there was no doubt that only a few had settled into my special friendship group.

Those few friends and I seemed to be living in the midst of a whole multitude of more or less meaningless people. But I

knew that now and then, out of that vague multitude, one would cut loose and join us. I supposed that I would never be able to have a great many friends at any one time. I could be on good terms with everybody, but my support would have to come from a few.

Mississippi told me that when school was out he would stay on in Bryan, Texas, to work for his Uncle Ed during the summer. His Uncle Ed owned a drugstore in that town, only a few miles from Texas A&M. But Mississippi said he certainly did not intend to work long in that drugstore, even if his Uncle Ed willed the business to him. "I don't intend to become baldheaded yet," he said. "All druggists are baldheaded, you know."

When the last class was over and all examinations had been taken, we needed only to turn in our rifles to Mr. Cheat'em.

Then we would be free to go to our respective destinations for the summer. Yelling around the campus had now become sporadic. Vacation was starting. Mississippi and I felt that the war we had waged for nine months against the sophomore class was, if not a clean victory, at least a draw. It was shocking to think that when we returned, we ourselves would be sopho- mores. It was almost inconceivable. Would we then have to acquire heavy board paddles and begin demanding that the freshmen pootch for us? We would have to wait and see. It was with sadness that I boarded the train for my hometown, a long ninety miles away. And if I had not realized I would be returning in three months, I would have felt bewildered.

CHAPTER VII

The Devils River

After I returned home from A&M, a whole week passed before I learned that Traynham Pitts was back. One afternoon he showed up at my house, which was across the street from the high school we both had attended. Together we noticed that the old brick building was closed for the summer. The sight of it brought back memories. Traynham and I had a long talk that day, but I never did learn exactly where he had been. He talked about New Orleans and about a girl he'd met there. He said he was eating a banana when it accidentally shot upwards and

came down into that girl's bosom. She retrieved it and handed it back to him. He said that was the way he had met her. He also told me he had been for a while in the Merchant Marine.

After that, Traynham and I started talking about a fishing trip I had taken with my father a couple of summers before. It was when I was still in high school. I had gone with my father and one of his old friends to the Devils River in the far western part of Texas. We had camped there under a beautiful pecan-tree grove right on the bank of that clear, rushing stream. The Devils River is only about thirty miles long, but more water flows through it each year than flows through some long rivers. There is a waterfall about every hundred yards along its course until finally the water reaches the Rio Grande River, or the Rio Bravo, as the Mexicans call it. In addition to the beautiful river itself, there are many sparkling creeks which run into it. The water of the creeks flows over and among white rocks and under willow trees to empty into the Devils River. When I was there with my father, the water was overpopulated with fish. You could see layers and layers of them, from near the surface to near the bottom. The water was that clear. The fish were largemouth bass, large perch, and channel catfish, along with a small percentage of carp. I noticed that the carp always remained at the lowest level with their heads facing upstream. They never seemed to go anywhere; they just remained at that lowest depth, letting the water run through their gills.

After I told Traynham about that trip with my father, he said, "Why don't we go there right away? I've saved up enough

money to pay for the gas." Traynham must have known that my father had given me a secondhand Ford touring car.

My father was always generous with me if I did things he liked to do. He had a great love of nature. He had gone as far as Mexico to camp and hunt. It pleased him if his sons liked hunting and fishing, and he always encouraged them in those sports. I suspect he felt also that such sports would keep his sons out of baseball and football, which he regarded as a waste of time. By this time my brother Hal had become a dentist and was practicing his profession in San Angelo, Texas. When Hal was younger, he had gone on several hunting trips with my father. He had caught the hunting and fishing "disease" very badly. But that was not true of my other brother, Ben. He told me he had outgrown hunting and fishing, and that he never again intended to "wet a hook." His way of seeing the life around him was so fascinating that he didn't need to have any other sport.

Traynham and I went to my father and told him we were thinking of going to the Devils River. I knew he would like that, but I was surprised at what he said.

"Why don't you boys take Paul Gee along with you, and of course Nellie, too."

Paul Gee had once been a slave, belonging to one of my relatives named Gee. That was how Paul got his surname. I got my middle name from that same family. Nellie, on the other hand, was a little bitch Airedale terrier dog my father had acquired. Nellie was about two years old. But no one knew how old Paul Gee was. He had always looked the same age to me. He

must have been pretty old, however, because he once told me he had heard the booming of the cannons during the Civil War Battle of Richmond.

Every member of my family loved Paul Gee. My father always called him "Saint," after Saint Paul, but I think all the others in our family called him either Brother Paul or Bro Paul. And Paul always called me "Bro Beencz," because of my nickname, "Beency."

After talking to my father, Traynham and I went to see Paul Gee. "Bro Paul," I said, "how would you like to go with Traynham and me on a trip way out west? We may go all the way to Mexico."

"Bro Beencz," he replied, "I'se ready to go anytime you say, even if you goes west of west."

* * *

Before we left on our trip, my father suggested we call our car "The Swan," so I proceeded to paint a big white swan on each side door.

It took us nearly two days to reach San Angelo where Hal lived. That small town was right on our route to the Devils River. The first night out we camped in a mesquite pasture, somewhere west of Brownwood, Texas. I chose a mesquite pasture to camp in because I've always loved such a place. To me a pasture filled with mesquite trees is a beautiful sight. The trees, with their dark gray, almost black limbs and delicate gray-green foliage, have a way of breaking through the space without com-

pletely blocking out the view. One can see quite a distance back into a mesquite pasture even when the trees are thick.

Because of this I was able to notice that we had camped in the vicinity of a prairie-dog village. Nellie had also discovered that village, and now I could see her running wildly from place to place, apparently chasing the little prairie dogs. When we all went closer, we found that Nellie was quite frustrated. Every time she was about to catch a prairie dog, it would suddenly disappear into a hole. Then I noticed something that Nellie also noticed. After a prairie dog had escaped into a hole, it would immediately come right out again and look in the direction from which it had come. I saw Nellie crouch on the far side of the hole into which a prairie dog had just disappeared. When it reappeared to have a look around, Nellie seized it from the rear. She had caught onto this tactic so well that I had to pick her up and tie her in camp to keep her from annihilating the whole prairie-dog town. Nellie, a dog herself, did not seem to realize that those prairie dogs were her relatives.

After arriving next day in San Angelo, Traynham and I went immediately to Hal's office in a downtown building. We surprised him busily grinding away on a girl's tooth. I think the patient was relieved when Hal put down his drill to talk to us. When we told him we were on our way to the Devils River, he said, "Dad burn it, Beency! Why didn't you and 'Transom' tell me you were coming? I might have arranged to go with you."

I was quite sure he could not join us for two reasons: he not only had a dental practice but also a wife. But in the end it was clear he had not given up. He drew a map for us right there in his office, to show us exactly where we should go, and he said flatly that he would join us in two weeks. I was a little concerned about interfering with Hal's dental work. His patient, however, did not seem to mind at all, and neither did the pretty dental assistant who seemed happy to be talking with Traynham.

When I thought more about it, I decided Hal might join us after all, just as he had said he would. I thought that because I wasn't at all sure he enjoyed being a dentist. After he was graduated in dentistry from Vanderbilt University and had begun practicing that profession, it wasn't long before he announced to my father that he thought he had been "called" by the Lord to be a minister or preacher.

My father was shocked to hear that. He took Hal to one side and said, "Listen, Hal, I have just spent several thousand dollars making you a dentist. I sold a small farm in order to send you to Vanderbilt. Now you just buckle down and start pulling teeth. The Lord has called you to pull teeth, not to preach. So

you just get busy pulling teeth, and don't let me hear any more about the Lord calling you to go forth and preach."

After that firm talk, Hal settled down reluctantly to his profession of being a dentist. Because of that, I now believed he really might show up on the Devils River.

* * *

After leaving Hal and getting onto the road to the Devils River, we finally reached the last ten-mile point. From there on, the road to our campsite was extremely bad. It led always downward, through brush and cactus-filled canyons. I was amazed that our old Ford car was able to get over that boulder-strewn trail. Paul Gee and Nellie, on the back seat, were often in each other's laps because of the bouncing they had to endure. But when we finally reached our destination, I saw that again I would be camping under beautiful wild pecan trees. A stone's throw away, I could see and hear again that breathtaking stream rushing along its way to join the Rio Grande. It seemed to be so self-sufficient. I knew that I could love it all I wanted to, but that it had no time for me personally. It was too busy taking its white water toward the sea. It was clear to me that we had reached paradise. There were no houses anywhere. In fact we had seen none after leaving the main road, some twenty-seven miles back. We knew we were on Russell Menzies' sheep ranch, because Hal had told us we would be. Russell was the son of one of Hal's older dentist friends. We had no idea, though, where Russell could be found.

We pitched our camp. We put up our tent and placed three cots inside it. We nailed a wooden box to a tree to hold our provisions. Darkness set in shortly after we had our living quarters established. Our supper that night was meager, but we intended to begin eating freshly caught fish from then on.

Paul Gee soon had a fire going out in front of our tent, even though the weather was warm. I was pleased he had built it, because a campfire looks good in any kind of weather. To be comfortable during the night, however, I tied the tent door-flap back and propped up the sides of the tent on short sticks. As we lay down on our cots, we could see out on all sides even while we had a roof over our heads. The never-ending sound of the rushing river a short distance away must have been sweet music to Paul Gee, for he began accompanying the music with his gentle snores the moment he retired. Although I had driven nearly three hundred miles that day, I was not aware of being tired, so I began asking Traynham some questions. I wanted to learn more about where he had gone when he dropped out of high school before graduation. I also wanted to hear more about that girl he had met in New Orleans.

"Tell me more about that girl you met with the banana," I said. "What was she like?"

Traynham said, "I can't get her off my mind, she was so pretty." He then went on with that story: "Did you ever see a crow up close?"

I said I never had seen a crow up close, because they would always fly before I could get close to them.

"Well," he said, "you must have seen a dead crow up close, and if you looked at its wing you would have seen the color of my girl's hair. It was as black as any crow's wing, and it glistened in the sun the way the light glistens on a crow's wing."

"You don't mean to tell me your girl's hair was like feathers, do you?" I asked him.

"No," he said, "but her hair was as pretty as the black feathers on a crow. And her teeth were as white as pearls. Her teeth were that white, and regular like the grains of corn on a corncob."

"Gosh," I said, "she must be a beauty."

"You wouldn't believe," he went on, "that a person's skin could be so white and smooth. And her figure was all curves, one curve flowing into the next. You could follow them with such ease that once you started looking you couldn't stop. Your eyes just kept going on all around her."

"What about her eyes?" I asked him.

"You wouldn't understand the beauty of her eyes," he said, "because you have never sailed way out on the deep ocean. Out there on some days, when the sun is shining bright and there is not much wind, you can look down into blue-green water that seems to have no bottom. That is the way her eyes were."

"Gosh," I said again, "she must be the prettiest girl in the world. She must be what you would have to call 'perfection itself.'"

"Well," said Traynham, "she was about as perfect as any girl could be. She did have one *slight* flaw, though," he added. "She was cross-eyed."

"Cross-eyed!" I exclaimed. "Cross-eyed, did you say?" I was shocked.

"Wait a minute," Traynham insisted. "Don't be so upset! This girl was cross-eyed, all right, but only in one eye!"

"Oh, well," I said, "I guess that does make a slight difference."

By this time the music of the Devils River was putting me to sleep. I began to dream of a lot of pretty, cross-eyed fish swimming in the river.

* * *

Several days after Traynham had told me about his pretty, cross-eyed girl friend, a handsome young man rode into our camp on a dark red horse. He was Russell Menzies, the sheepman. When I told him who we were, he was very cordial and welcomed us to his ranch. He said he was camped in a tent up the river a couple of miles and that just this side of his place the Dunagan family lived in a tent. I think Mr. Dunagan was his foreman. Although I had found that the river was still swarming with fish, Russell said he and the Dunagans never had any fish. He said they didn't have any fishing tackle, so they lived mostly on goat meat. Apparently a few goats were kept among the sheep for food. The sheepmen seemed to prefer goat meat to mutton or lamb. I told him we would catch fish for him any time he wanted a change of diet.

Traynham Pitts, Paul Gee, and I never seemed to tire of those bass and channel catfish. I cooked them in a big frying pan in boiling-hot cooking oil. Paul Gee would make a fire in a rock stove I had made against a big boulder. The boulder was about five feet high and five feet wide. It had a big crack in it. Somewhere back in that crack lived a rattlesnake. This we knew because every time Bro Paul built his fire against the boulder, the rattler inside would start rattling. It must not have liked the heat. But it would never come out. We decided we would just have to live with that rattlesnake, although Bro Paul didn't like to hear that rattling at all.

One day, while I was walking up the river, I met a girl wearing tight Levis. She was so pretty and her eyes were so blue that I thought to myself she must be Traynham's banana girl.

But this girl was certainly not cross-eyed. It turned out that she was Sky Dunagan, and that she lived with a sister called "Toots" and their father in the tent down the river from Russell's camp. I think the mother of the girls had died. I thought the name "Sky" just suited this beautiful sheep girl. I wished I could paint a picture of her and call it "The Sheepherder's Daughter." She was very friendly and insisted that we come to see them.

When I went back to our camp, I told Traynham I had found his New Orleans girl up the river and that she had invited us to come up and visit. Traynham was so delighted he said, "Let's go right up there tonight!"

Russell Menzies had told us that in addition to the kind of fish we had seen in the river, there was another kind, which lived in the deepest places, called "yellow catfish." He said they

110

weighed up to ninety pounds. I knew that would excite Traynham, so I wasn't surprised when I saw him tying some big fishhooks to several lines.

"I'm going up the river to put out some set-hooks for those big catfish," he said. "I'll leave the job of catching bass for supper to you this time." And off he went with some kind of bait he had faith in.

We had supper a little early that afternoon. When Bro Paul built the fire against the boulder this time, the rattler really rattled loud and strong. Bro Paul kept saying as he built the fire, "You old devil snake, I wish you would go away from here." I told Bro Paul always to watch his step, because that rattler in the rock was not the only one around our camp.

Just after dark the three of us started up the trail to visit the Dunagans. We took along a small kerosene lantern, the only light we had for the night.

After we had gone about a quarter of a mile up the river, Traynham stopped and said, "I put one of my set-hooks over there beyond those small trees near the bank. Let's see if anything is on it."

I handed him the lantern and followed closely behind him. We were stooping to go under some low limbs near the bank when suddenly a rattlesnake began rattling right up near our heads. Traynham lifted the lantern, and there we saw the snake on a limb. It was a short rattler, and it certainly didn't have to coil in order to rattle. The snake was only about a foot long, but I knew it was dangerous. We later learned that those small rattlers were common in the area. The sheepmen called them "rock

rattlers." I was especially disappointed to know that from now on we would not only have to watch our step, but also watch out for rattlesnakes up on tree limbs. There was nothing on Traynham's set-hook, so we proceeded up the river toward the Dunagan camp.

When we got near the camp which was under huge pecan trees, we saw that the Dunagan living quarters were more than the usual kind of tent. The dwelling had a large plank floor with wall boards extending upward about three feet on all sides. From that point on up, the walls were of canvas, as was the roof. As we approached we heard much laughter inside the tent, and we could see weird black shapes on the canvas walls. A great commotion seemed to be going on. Everybody inside was laughing uproariously, and we judged from the shadows on the canvas walls that everybody was jumping up and down. We soon learned the cause of all that commotion. Someone in the tent suddenly had found that a rattlesnake was inside with them, and they were all excitedly trying to kill the snake. The one who finally killed it was beautiful Sky. She smashed its head with her boot. I knew she would be the only girl I would ever know who killed a rattlesnake by stomping on it with her feet.

We had a good visit that night with those nice people, including Sky, whom I had already met, Mr. Dunagan, and Sky's older sister, Toots. They all seemed enchanted with Paul Gee. I doubt if they had ever met a black man before.

Down the river from our camp, a short distance away, was a waterfall. It was larger and much higher than some of the other falls nearby, and it had a name. It was called Dolan Falls.

112

One day I asked Paul to go with me to fish on the other side of the river. "Bro Paul," I said, "you can go with me across the river and help me catch some grasshoppers. I think I can get some channel cat if we can find some grasshoppers."

The rocks were so situated at the falls that it was easy to step from rock to rock and get across the river, even though the water was making a terribly loud noise rushing between the rocks and falling. It really was easy to get across. But when Paul Gee tried it, just in front of me, the noise of all the water falling got him confused, and to my surprise he slipped and fell into that part of the water that was just going over. Paul went along with it, and in a second he was out of sight. But he was not alone, for I followed him down. Now the two of us were together in a deep, agitated pool with a white wall of water behind us. I took hold of Paul, and soon we managed to make our way through the waterfall. We found that we were then on a ledge behind the wall of falling water. I thought we had better sit there a moment and decide the best way to get to the near bank. I knew there was no danger at all, for we were both good swimmers. But just a moment later I was disgusted to find we were not the only occupants of that ledge. A few feet from us, taking life easy, was a big rattlesnake. Apparently it had fallen into the river, also.

"Sit still!" I said firmly to Paul. "I'm going to get that snake out of here." Grabbing a dry limb nearby, I managed to shove the snake into the boiling water and send him down the rushing Devils River.

I had lost my fishing pole, so Paul and I arrived on the far bank without any fishing tackle. With my help and encouragement, Paul managed to step from rock to rock, and we got back to camp without further trouble. But I had to start fishing for bass on my side of the river if we were to have fish for our supper.

* * *

A few months before summer vacation, Leon Black had introduced me to Buck Schiwetz who was the art editor of the A&M college annual. Buck had asked me to make a couple of drawings for the book. He had also given me a scrapbook full of illustrations he had clipped out of other books and pasted in. Many of the illustrations were in color. I enjoyed looking at those pictures. I decided I would try to make some myself, even though I had never studied art. I had only drawn that banana and a few chickens when I was a child. So I bought some oil paints, canvas, and a small folding easel to take along on this trip to the Devils River.

One day I went up the river and set up my easel right on the riverbank, next to the trunk of a big pecan tree. I began trying to draw and paint the scene before me. After about twenty minutes I got up and backed away to see how my painting was coming along. When I looked at the lower part of my canvas, I saw that I had been sitting next to a big rattlesnake which was peacefully lying right next to where my left foot had been. Its head was resting on a piece of bark of the tree trunk as though it

had been watching me paint. I should not have done what I did, but I was so frightened that I got a long stick and killed the snake. Then it occurred to me that since Traynham was somewhere up the river hunting tree squirrels, I should place the dead snake in the pathway he would later take on his return to camp. After putting the snake there, I gathered up my materials and returned to camp myself.

A short while later Traynham walked into camp. He made it clear to me that he was annoyed. He would barely speak to me.

I said to Traynham, "What's eating you this morning?" I had forgotten about leaving that snake in his path.

"You ought to know," he answered. "You put that damn snake in my path."

"Oh, well," I said, "it was dead. I thought I would play an innocent joke on you. You couldn't have gotten bitten."

"That's what you think!" he said. "When I jumped to one side to avoid that dead snake, I almost landed on another one that wasn't dead. It's a wonder I wasn't bitten!"

I told Traynham I was sorry, and that I would not do that again. I hadn't realized the snakes in this area were as plentiful as that. Another reason I was sorry I had done that to Traynham was that he had tried to do me a favor the day before. While attempting to make a painting up the river, I had become so disgusted and frustrated with the way my painting was turning out that I had simply thrown it into the rushing river. It happened that Traynham was fishing down the river when he saw

my canvas floating by at great speed. He had dived into the river with all his clothes on to save it.

When I got to camp, there was my wet painting leaning against a tree trunk. It was still no good, but I think it looked a little better after the soaking it had received. I just left it where Traynham had leaned it against the tree. For days after that, every time Paul Gee would wash dishes he would throw his dirty dishwater in the direction of my painting, and it would get a good splashing. As the days went by, the painting got to looking better and better. I think that was my first art lesson. I thought to myself that if I could figure out why that soapy dishwater made my painting look good, then maybe I could make a painting that would not need to have dishwater thrown against it.

* * *

When Russell Menzies rode into our camp one afternoon and asked me if I would like to go with him to get a goat, I was delighted. I said I would love to. Since I had been providing him with fresh fish lately, I imagined I was about to receive a piece of goat meat. But I did not know what this goat invitation involved.

"You just get up behind me," he said, "and we'll ride out among the sheep until we find some goats. When we get near them I want you to slide off behind and run and feel their tails until you find one that's very fat. If a goat's tail is fat, the goat will be fat."

"O.K.," I said, "you tell me when." This would certainly be

a new experience for me, since I had never felt a goat's tail in all my life.

I got behind Russell on his dark red horse, and we took off in a direction that led away from the Devils River. I was impressed by the way the landscape changed so drastically the minute we moved from under the pecan trees near the water. We were now among low brush, and every growing thing was covered with thorns.

Soon we came to a gently sloping area where the bushes were quite low with open places between them. Many sheep began to appear all around us, but no goats. I was surprised to see how long the sheep's tails were. Russell told me that was because the tails also produced lots of wool and therefore were allowed to grow long.

Suddenly I saw a goat among the sheep, and then several goats. I did as Russell had told me. I slid off the rear end of the horse and rushed toward the goats. I began to feel their tails. I had to make some comparisons before I could decide. I found, after I had felt about six goat tails, that the one I had felt first was the fattest. Fortunately I still could see where that one had gone. When I ran and caught up with it and grabbed its tail, I knew I was right.

"This one!" I shouted to Russell.

It did not take him long to overtake the goat and from his horse throw a rope around its neck. Russell then got down and in no time had the goat's feet tied together. He put the goat up on the horse, in front of the saddle. I got on behind, and he delivered me back to camp.

"I'll send you a dressed goat leg tomorrow morning," he said, as he let me off. We would have bass that night, but I knew tomorrow it would be goat. And I also knew my brother Hal was due to arrive that afternoon late.

Paul Gee, who was still grumbling in camp about that rattlesnake inside the rock, told me that Traynham had gone off with Nellie. "He say they gonna catch a civic cat," Paul said. I knew Nellie had been chasing ground squirrels, the way she had chased those prairie dogs, and that she had never caught one.

When Traynham came into camp with Nellie, he reported that she had chased a "ringtail" into a rock pile. "It was so pretty I wouldn't let her catch it," he said. "It had a long bushy tail with many rings around it. Mr. Dunagan says it's also called a 'civet cat.'"

I told Traynham about the goat leg we were to have next morning. "That's great," he said. "I know just how to cook it. We'll have it for supper when Hal gets here."

The next morning, after a Mexican boy had delivered the goat leg to us, Traynham took a shovel and dug a hole about three feet deep. He then sent Paul for wood and had him make a big fire out of dry pecan limbs. He had Paul build the fire next to the hole.

"We'll bake that goat leg under the ground," he said. "It will take all day."

While the fire was burning down, Traynham put salt and pepper all over the meat and wrapped it up, first in old newspapers and then in a wet dishtowel. He then shoved into the hole lots of hot coals from the fire. Next he shoveled dirt on top of the

coals and smoothed the dirt down. Then he placed the wrapped meat on top of the dirt. After covering the meat with more dirt, he raked in the rest of the coals. Next he filled the hole completely with the remaining dirt. And to my surprise he now built a big fire on top of it all.

"That is going to be the best meat you ever smacked your lips over," he said.

"Well, I hope so," I said, "but in my opinion we are going to have charcoal for dinner. I'm going across the river and catch a couple of channel cat, just in case."

Hal arrived, as he had said he would, about 5:30 P.M. Traynham told him about the goat feast we were going to have in celebration of his arrival. I had staked out my two channel catfish in the river, just below our camp.

"Set the table, Bro Paul," Traynham now said. "The biscuits will be ready in ten minutes." Traynham had made a whole batch of biscuits, which were being cooked in the Dutch oven, an iron object with an iron top that would hold coals. Traynham had made a wire hook for lifting the top off, and he now lifted it. "Just about nine minutes more," he said. "I suppose we really should wait till after dark for supper, because those biscuits are going to be as good as the goat."

I knew why he said that. We had found that if we ate in the dark we didn't notice the small ants that had got into the syrup bucket. There was no way to get them out, and we had found that they didn't seem to have any taste anyway. As it happened, that delay would not be necessary, because Hal had brought an unopened bucket of syrup.

"Now for the best roast you ever tasted!" Traynham bragged. Then he began to dig.

I had doubts about that cooking operation, but I also had respect for Traynham's many talents. So I watched with interest as he continued to remove the dirt from the hole. After he had removed the top dirt, he arrived at the bed of coals. He removed those coals and arrived at the second layer of dirt. I knew the meat would come next. He now proceeded to dig more slowly and carefully, but I began to notice some black particles coming up with the dirt. Traynham got onto his knees, and, with his hands on the lower end of the shovel handle, started taking out what he was finding. When he came up with a couple of black, charred knucklebones, I knew all was lost.

Bro Paul must have seen those charred bones also, for he exclaimed, "Dar now, Bro Beencz, Bro Traynham have done burnt up de goat! He done sacrificed de ram for Abraham!"

Traynham took a long look down into the hole. Shaking his head from side to side, he said, "Well, I'm a suck-egg mule! This is the first time that has ever happened to me."

"Don't worry," I hastened to say, "Hal would rather have fresh fish anyway. He has probably been eating goat meat every day at home and hasn't had any fresh-caught fish for a long time."

We had a happy fish dinner with wonderful golden biscuits out of that Dutch oven, but we all agreed we would not tell Russell about what happened to his delicious culinary gift.

* * *

About fifty yards up river from our camp a deep draw led down to the river. When the river had overflowed sometime before our arrival, a big pool of water was caught in that place. There must have been a spring inside the pool, for a thin trickle of water ran constantly from it into the river. But the pool of water always remained deep and about forty feet wide.

Russell had told us that on the following Sunday he was going to have a picnic at that pool. He said he had invited all the cowhands and sheepherders in the vicinity to come to his party and that we were also invited. Since all the ranches were large, the people would be traveling fairly long distances to get to the picnic.

The day before the event, we noticed that tables and benches had been moved into the area near the pool. Next morning early, lots of food and beer were brought in. Traynham Pitts was so excited about the coming picnic that on Saturday afternoon he shaved and took a soap bath in the cold river. He tried to persuade Paul to go in with him, but Paul said he did not need a bath. That amused Traynham, so he questioned Paul about it.

"Who said you didn't need a bath?" Traynham asked Bro Paul. "We've been gone from home three weeks, and the only bath you've had was nearly two weeks ago when you accidentally fell into the river."

Traynham kept insisting that Paul go with him down onto a flat rock at the edge of the water and take a bath. Finally Paul agreed. I could see them both down there taking their clothes off—Traynham, whose skin was pure white, and Paul Gee, who was as black as a shoe. Paul was also quite small, although very

strong and muscular. My father had told me once that he thought some of Paul's ancestors might have been African pygmies.

Soon, when I looked again, the scene had changed slightly. Traynham, covered with soap, was no whiter than before. But Bro Paul was now about as white as Traynham, for he was covered with soap, also. Then I watched Traynham dive into the river and come up shivering and yelling because of the shock of the cold water.

"Come on in!" I heard Traynham say to Paul. But Paul, still white with soap, lingered on the rock.

"Come on in!" Traynham ordered again.

Paul still didn't make a move toward going into the water. Then I noticed that Paul had his head down to one side as though he was smelling the soap.

"Bro Traynham," I heard him say, "this soap smells so good, I'se decided just to leave it on." And with those words he started reaching for his clothes. But he didn't get away with it. Traynham jumped back onto the rock, and I heard a big splash. Bro Traynham Pitts had shoved Bro Paul Gee into the cold Devils River. When he came up, yelling, the soap was gone and Bro Paul was as black as before.

Next morning quite early the sheepherders and cowhands began arriving. They had driven in their cars first to Russell's camp. They must have gone there over a road we didn't know about, since we did not see them until they began arriving on foot at the picnic site. Paul Gee had just finished the breakfast dishes and had thrown his dishpan of soapy water against my

122

painting when I looked up and saw the guests approaching the deep pool. It was a colorful sight, for they wore brightly colored handkerchiefs around their necks, both the men and the women. They were dressed alike, the women wearing cowboy hats as big as those of the men, and everyone wearing high-heeled boots. I had imagined that Sky and Toots might arrive in dresses on this special occasion, but there they were, in their everyday outfits. Traynham said Toots must have been melted and poured into her Levis, since there was no other possible way she could have got into them.

I was especially interested in meeting these ranch people, because of what Sky had told me. One day, when I found her seated on a rock close to the river's edge, she said to me that she was worried about her future. "I don't want to become a sheepherder's wife," she said. "I don't want to spend my life living on this river, in a tent among sheep. Toots knows just what she wants. She wants to get hold of a big spread and manage it all by herself, with or without a husband. But that is not for me."

I told Sky that I thought nothing could be more beautiful than living on the Devils River. As I told her that, I was thinking she would probably do just that, because she would have no choice. Some sheepherder would fall for her, and she would marry him. Nobody ever wandered far from this ranch country, I thought.

But when Traynham, Paul Gee, and I walked around the pool and joined the party, the first cowboy I met began telling me

about a trip he had just taken all the way to Los Angeles and back.

"It is much better here where there is a lot of open space," he said. "I don't like those crowds, and to make matters worse, somebody in Los Angeles stole my hat. I laid it down on a bench, and the next thing I knew, I didn't have a hat." He went on to say that he had walked all over Los Angeles and Long Beach, bareheaded, trying to find a store that sold men's hats. "They just don't have hats for men in Los Angeles," he said. "Finally I did find what they called a hat. It was such a dinky thing that, although I bought it, I was ashamed to put it on my head. I carried it in my hand from then on until I got back to Texas."

My first thought was that here was a man who might be all right for Sky. He had been all the way to Los Angeles. But I had no sooner had that thought before he began talking again. This time he said, "You couldn't pay me ever to leave West Texas again!"

I was curious to see what was being cooked in a big pot nearby, so I went over to a Mexican who was standing beside it and asked him what he was cooking. He said to me, with a grin on his face, "I dough know. Cowboy, he call him 'sonofabeetch.'" What he was making was some kind of stew. I saw there was corn in it, and potatoes, lots of canned tomatoes, chiles, and some kind of meat. And judging by the size of the pot, I was certain there was going to be enough "sonofabeetch" for everybody.

* * *

Now Toots and Sky came over to tell me that soon a big swimming race was to take place across the pool. Sky wanted to know if we had swimming suits. I told her I thought we did. "We have an extra one for Mister Paul Gee," she said. We were asked to go put on the suits right away, because the race was to be before lunch. She gave me the gray bathing suit she said was for "Mister Paul Gee."

When I found Paul Gee and told him about the swimming race, he didn't like the idea at all. I assured him the Dunagan girls would be disappointed if he didn't enter the race.

"I jes don't want to be swimming around with all them white folks," Paul begged. But I insisted that all these western people liked him and expected him to take part. Another thing Paul did not like was the cold water.

Traynham and I went immediately to our tent and put on our suits. Bro Paul then went into the tent and said he would soon be ready to join us. When Traynham and I returned to the pool, we found that nearly all the contestants had arrived there. Sky was coming down the bank in a blue bathing suit, and my eyes settled upon her. I think I was finding again those rhythmic lines I had seen when I walked behind the Switzer girl in high school. But suddenly there appeared in the corner of my eye a powerful distraction that pulled my attention away from beautiful Sky. Bro Paul was coming slowly down the trail that led to the pool. He had on the gray bathing suit, and his body seemed to be warped out of shape. There was a big bulge around his waist and one just above each knee. His wiry arms and legs seen against the gray suit were as black as India ink.

About fifteen people were now ready to take part in the race. They were standing at the edge of the pool, and when Paul arrived they insisted that he take a position in the middle. He made a striking centerpiece in that line, for nobody was at all like him. The only visual competition he had, except for beautiful Sky, was one young cowboy who wore a swimsuit covered with wide black and yellow stripes.

Russell called the swimmers to attention and explained that he would count to seven and then fire his pistol into the air. At the sound of the gun everyone was to dive into the pool and head for the opposite bank.

When the pistol went off, there followed a loud and somewhat prolonged splash, and the race was on. Water was splashing all over the place while the swimmers were moving toward the far bank. Soon there was a line of swimmers moving like one big wave toward the goal, except for one lone swimmer. Brother

Paul Gee was lagging behind, and those on the far bank who had not entered the race were yelling, "Come on, Mister Paul! Come on, Mister Gee! Come on, Brother Paul!" But Paul had slowed down. He was stroking mightily with his arms, but he wasn't making any headway.

When all the swimmers had reached the far side and were climbing out onto the bank, Bro Paul was only about three-fourths of the way across. Finally he did reach shore and began crawling slowly onto the muddy bank. As he pulled himself out of the water, we saw trailing behind him two long white streamers, which also covered his legs and feet. Bro Paul had to crawl about eight feet up the bank before those long streamers cleared the water.

Because of his extreme modesty, Bro Paul had put on beneath his bathing suit a pair of long winter underwear. He had managed to tuck this garment up and out of sight before entering the water, but once he had dived in, both legs of the underwear had come down past his knees, past his toes, and on out behind for about four feet. That was what had been holding him back in the race. Of course he lost the race, but because of the entertainment he provided he was now the hero of the picnic.

When we went back to camp to change our clothes, I asked Bro Paul where he got such long underwear.

"I thought it might get cold way out west," he said, "so I brung along de union suit Doctor Conrad done give me last winter."

CHAPTER VIII

The Rio Grande
and the Pecos

We had been on the Devils River over a month, and although the days had gone by fast because we were so content there, both Traynham and I thought we should move on. Traynham was anxious to visit a Mexican village across the Rio Grande by the name of Villa Acuña.

We told Russell and the Dunagans good-bye and were soon packed and ready to leave our camp. I was a little disturbed

by the way I felt when I told Sky good-bye. It really did seem to me that I was leaving someone very precious behind me. But I think something inside was telling me that Sky was only a faint suggestion of a much more precious and mysterious black-haired girl who was waiting somewhere out in the future.

Traynham now said he would like to drive for a while, so I took the front seat next to him while Paul Gee and Nellie settled again in the rear among all our equipment. The trail that led out to the main road, which was about twenty-seven miles away, was rough and rocky. It led through deep canyons and over a number of cattle guards. Because of the spaces between their cross bars, cattle guards could not be crossed by cattle. An automobile, however, could cross them with no difficulty. The cattle guards all had a vertical post on each side, which was where the barbed-wire fences terminated. The space between the posts was just a little wider than a car. As we were driving along, a big bull snake about eight feet long ran across the road and into a hole under a nearby bush. I got Traynham to stop the car. I could see the snake's tail sticking out of the hole by about a foot and a half, and I thought it would be interesting to catch hold of its tail and pull the snake out of the hole. That was a silly impulse, but at the time it seemed a logical thing to do. I ran to where the big snake's tail was sticking out. I got a firm grasp on it and began to pull. But to my alarm, instead of resisting, the big snake cooperated with me. It simply turned right around and came back to where I was. I fell over backward and the snake went right over me and kept going. Paul Gee got the biggest laugh out

of that incident. He said, "Bro Beencz done kotch a big snake, and de snake done kotch Bro Beencz."

The fright I had from that snake, however, was nothing compared to the fright given me by Traynham each time we would arrive at a cattle guard. Traynham would then do what he always did when he played baseball. Just before a ball arrived to be caught, he would begin to shake, and often the ball would go through his glove. As he drove rapidly toward a cattle guard, he would begin to shake and would aim the car at one post and then the other. I would shut my eyes, expecting him to knock both posts down and wreck the car. But at the last second he would cause the car to dive through the space between the posts. It was a nerve-racking experience.

Finally we reached the main road and turned west. We soon arrived at the small town of Comstock, Texas, where we stopped to let Traynham get some Bull Durham smoking tobacco. We had not been there a half-hour when Traynham announced that Nellie was in heat and that he had seen her take off with a big black and red hound dog. Traynham proved to be right. The next time we saw Nellie she was connected tightly to that big hound dog, and we had to wait a couple of hours in Comstock, Texas, before she could go on with us. Had we left earlier, we would have had to put two dogs hooked together onto the back seat with Brother Paul.

When we arrived that afternoon in Del Rio, Texas, we knew we were near the Mexican border. We found a so-called "tourist park" on the edge of town. A swift, clear stream of water called San Felipe Creek ran through that park, which was really little more than a large mesquite pasture. In the park, there was a wooden building with a sign at one end that said, "women" above and *"mujeres"* below. At the other end of the building a similar sign said "men" above and *"hombres"* below. At that time in my life I could not speak or understand the Spanish language, but without realizing it I was beginning to learn. *Mujer* and *hombre* became known to me that day, and those words were followed by *hoy, gran éxito,* and others.

We spread our large tarpaulin on the ground under the mesquite trees, and put up our three folding cots side by side upon it. We were at the far west end of the pasture. Through the mesquite trees, we saw there was only one other camp in the tourist park. It was located at the far east end, about the

132

distance of three blocks away. The back-seat area of "The Swan" was our pantry and refrigerator. We had replenished our grocery supply at a Mexican store in the village, and we now prepared our supper. There would certainly be no fish. That first night we had "light bread," beefsteak, and beans. We had built a fire, over which we cooked our steaks on a green mesquite stick, right in the flames. The beans had come from a tin can.

When we retired for the night, Traynham, who was smoking his Bull Durham cigarette while lying on his cot, brought up the subject of vinagaroons and vinagarees. "We had better not let any of our bedclothes touch the ground in this part of Texas," he warned. "That cowboy at Russell's picnic said that vinagaroons are very plentiful around Del Rio, Texas. He also said vinagarees are, if anything, even more deadly."

"What do them bugs look like?" Bro Paul asked.

I said I didn't know, because I had never seen one up to now, but that the cowboy had said they were worse than a rattlesnake.

"If one bites you in your sleep," Traynham added, "you just keep on sleeping; you never wake up after that. That is the end of you on this earth. And what's more, Bro Paul, that cowboy told me they are as thick as fleas all around Del Rio, Texas. People around here are dying like flies each day from vinagaroon and vinagaree bites. He said they keep the undertakers in business in this town."

"What do them things look like?" Paul asked again.

"Well," Traynham said, "that cowboy drew me a picture of one so I would know. A vinagaree is just a little smaller than a

vinagaroon, but just as bad. They both look like a stinging lizard, but are a little bigger and more reddish in color. Bro Paul, if one stings you, then you had better start praying fast."

"I'se gwine to start praying before he stings me," said Bro Paul.

I do not know how long I had been sleeping that night when I was suddenly awakened in a most unusual and startling way. I was flat on my back on my cot when my eyes came open, and I found myself staring into the eyes of a blond girl, her face not more than six inches from my own. She was stooping down low looking into my face as she stood by the side of my cot. I saw that she was wearing a thin white nightgown. Her arms were bare to her shoulders. I automatically seized both her wrists. She did not utter a sound, and neither did I. A bright moon had come up after we had gone to sleep, and it was now as light as day.

The girl did not struggle to get away, perhaps because in my fright I was holding her wrists so tightly. I decided to release her, but first I let go only of one wrist. With my other hand I reached over and shook Traynham. When he raised up on his cot and I was certain he had seen this silent stranger, I released her other wrist. She immediately started gliding away into the bright moonlight in the direction of the other camp. I watched this white apparition recede into the distance among the mesquite trees, and so did Traynham. He was dumfounded. Bro Paul never waked up.

I decided that she was either a sleepwalker or that she might have visited that house with the *mujeres* sign and then

134

become disoriented when she came out, coming to our camp instead of returning to her own. I thought she might have been trying to recognize someone of her own group when I found her staring into my face.

We made our breakfast early the next morning. We fed Nellie all the scraps of meat left over from our supper and began to pack up. We intended to drive that day to the border and cross over into the Mexican village as soon as possible.

Bro Paul had brought a bucket of water from the creek and was now busy with the dishes, so Traynham began folding up Paul's bedclothes. "Hey! Bro Paul!" Traynham suddenly shouted. "Look here! You were asking me what a vinagarce looked like. Here is one, right here in your quilt."

Traynham had found a vinagaree, which Bro Paul had been sleeping with. Bro Paul had smashed it during the night while he slept.

Bro Paul came right over to see. "Dat ar a vinagaree?" Paul asked seriously. He then took a close look at the scorpion-like object. "I sho done slept with that bug!" he muttered. "But I

done spent some time **praying** when I first got on my cot. I shake my quilts from now on, **praise de Lord.**"

* * *

Perhaps Traynham had been impressed by the way those cowboys and sheepherders had looked in their big hats at Russell's picnic, for when he saw a store with such hats for sale in Del Rio, he immediately bought one. We now had a cowboy driving our car as we went on toward the border.

We found we could cross over without any difficulty. I had been afraid the Mexicans might not let Nellie across, but no questions were asked. On crossing that border, I immediately felt good. I seemed to have an instinctive liking for Mexicans. They appeared to me to be exotic people. I had never believed all I had heard about them in connection with Texas history. I longed to go deep into the interior of that country.

The village of Villa Acuña in the summer of 1920 was not like any place I had ever seen. There seemed to be only one street in the town, although I did notice a number of adobe houses scattered about, a short distance away. When we started walking along the street, it seemed to us there was only one thing for sale. All the buildings were *cantinas,* and what they had for sale was beer and different kinds of Mexican liquor. At the far end of the street I did notice a building that had a sign on it with the long word *"abarrotes."* I soon learned that word meant "groceries." I now had added two new words to my

Spanish vocabulary: *cantina,* meaning "saloon," and *abarrotes,* meaning "groceries."

When we began going into the *cantinas,* we found other interesting things. Standing near the bar in each *cantina* were girls dressed very skimpily to reveal most of their bodies. Some of the girls were pretty, and I was surprised that some of them were so white, not like the usual Mexicans at all.

When Bro Paul saw those girls, he said he was going back to our car and wait for us with Nellie. But Traynham proved to be very knowing. He bravely went up to one of the prettiest girls and offered to buy her a drink. We both took a glass of beer while the girl took a small whisky glass full of something which I suspected to be water. Traynham then went over to a slot machine, and he began putting coins into it and pulling down a handle. He was putting American quarters into it, and I was thinking how foolish he was to be throwing his money away. Suddenly it seemed that all hell had broken loose. Lights began to flash, and it looked as though the machine was falling apart. Traynham took off his big hat and held it to the machine, which was now filling his hat full of quarters. Bro Traynham had hit the jackpot! When we got back to the car, we counted his coins and found he had twenty dollars in American quarters. In those days that was lots of money.

Traynham, now that he had made so much money, seemed to want to make more. He said to me, "We can make some good money in this place if you want to. I think I can get you a job to paint a picture on the wall of one of the *cantinas,* if you'll do it." He then asked me if I could paint a big nude woman. "If you

138

can," he said, "I know I can sell the idea to one of the bartenders."

Perhaps I was wrong in turning down that suggestion, but I had never painted a nude woman; in fact, I had never seen one. All I had been painting recently were pecan trees, and even those paintings had to have Paul Gee throw soapy water on them before they were any good.

*　*　*

We did not tarry long in the interesting Mexican village of Villa Acuña. We crossed the border back into Texas and found a place to camp for the night. Since I did not have to return to A&M for two months, we decided to make El Paso, Texas, our next goal. But when we finally reached Alpine, Texas, and consulted our map, we decided to go first down into the Big Bend country. On our map we saw a place called Terlingua, right near the Mexican border, so we made that our next destination.

The road over which we traveled south was altogether a dirt road. It led through beautiful scenery, up and down mountains at times, and across deserts through a bewildering variety of desert plant life. But although it was dirt, it was never a bad road like the one leading down to the Devils River. When we stopped for lunch along the road, we noticed that at the place where we had stopped someone had built a fire sometime in the past.

Traynham pointed at the charred spot and said, "A Mexican built that fire."

"How do you know that?" I asked him.

"Because there are no ends of the sticks left," he replied. "When a Mexican builds a campfire, he even burns up all the ends of the sticks. An American doesn't do that. He figures there is plenty of wood, and besides, why waste the time it takes to do it?"

I thought that Mexican was right to burn the ends of the sticks, and I also thought he showed a more becoming attitude toward nature. We were now in a part of the world where nature had obviously not been disturbed by people. It seemed to me, as I looked near and far, that there was something sacred in what I was seeing.

"We are in God's country," I said to Traynham. "Nobody but God owns everything we are seeing from this spot."

Terlingua turned out to be a remote and lonely place. All we found there was a company mining store. The man who ran the store informed us that there was a quicksilver mine nearby and that it was shut down. He also told us that several miles from the store the Rio Grande River came out from between two high cliffs. We went immediately to that place and camped.

The beauty we found at the mouth of that canyon where we camped was almost shocking. The river was rushing out from between two cliffs that went straight up toward the sky for hundreds of feet. The river looked as though it were flowing steeply downhill out of that canyon. The sheer cliff on the far side of the river was a little lower, and we knew it was in Mexico. On our side of the river there was a stark and uninhabited desert, except for one adobe house about a mile away. Not a

tree was in sight, nor was there any wood of any kind with which to make a campfire.

We now asked Bro Paul to walk out into the desert and try to find enough twigs for a small fire over which to cook our supper. Traynham had an idea about what he and I should do.

"While Bro Paul is searching for firewood," he said, "let's see if we can go up that canyon."

Clearly there was no way to go up the canyon except by swimming, for the swift river extended from one cliff side to the other. However, when we walked to the river's edge, we could see some ledges a foot or two above the water, but it would be necessary to swim to get to them. I told Traynham that we had better help Paul find some wood. It was getting late and we could tackle that canyon the next morning.

We could see Bro Paul coming across the flat desert toward camp, so we waited for him. Nellie was with him, and when he came near we could hear him talking to her. "You ought to be 'shamed of yoself," he was saying. "You ought to be 'shamed of yoself for taking up with that strange dog. You never see that dog befo, and you done run off and took up with him."

It turned out Paul had found only a few clumps of dry grass, and when Traynham and I went looking for wood ourselves, that was all we could find. With that grass we never succeeded in getting our coffee to boil. Our supper that night was warm, weak coffee with grounds floating in it, Mexican bread, and canned beans. And that is about all we had the next morning for breakfast.

As Traynham and I were taking our clothes off to go into the river, Bro Paul announced that he was going over to that adobe house and "see what dem folks use for wood." Traynham and I then jumped into the swift river and began swimming against the current. We soon found that we could climb onto the ledges. We would follow one along until it played out. Then we would jump into the river again and swim until we came to another ledge. In that way we managed to go around a bend in the canyon, where we saw, several hundred yards ahead of us, a sand bar extending out from the Mexican side of the canyon. When we finally reached it we were then about three-quarters of a mile up the canyon. And there on that sand bar we saw something we would never have expected.

A little goat had fallen from a ledge high up the side of the canyon, and it was now stuck almost up to its neck in quicksand. It was surely doomed, for it could never have extricated itself.

Traynham and I began digging, and we managed to free the goat. We then began swimming downstream with it. I don't know whether it was a wild goat, a Mexican goat, or an American goat, but we had certainly saved it from a slow death by starvation.

When we swam out of the canyon and got onto the river bank, our little goat was so weak it was barely able to stand. Bro Paul had returned from his visit. He told us the inhabitants of the adobe house were Mexicans who could not speak English. He said he could not find out what they used for wood.

"Let's give this goat to those people," Traynham suggested.

"Are you sure you don't want to dig a hole and cook it, the way you cooked that goat leg Russell gave us?" I asked. Traynham knew I was joking, but he reminded me that there was not enough wood for that.

So, carrying the little goat whose life we had saved, we started walking toward the adobe house, which we could see in the distance. As we drew nearer we noticed what appeared to be a cloud of dust arising at intervals from one side of the house. We soon learned what it was. The Mexicans were threshing a pile of wheat. They were winnowing out the chaff by throwing the wheat into the air. The wind would remove the chaff and take it away while the wheat grains would fall back onto the ground. That was a very primitive way to thresh wheat, which I had never seen before.

We gave that little goat we had saved from starvation to those nice Mexicans. They thanked us and seemed pleased by our gift.

When we got back to camp, Bro Paul was laughing. "Now just what are you laughing at, Bro Paul?" Traynham asked.

"I'se laughing at you done save de goat's life, but you done turn round and take dat goat outa de fryin' pan and den put dat goat into de fire. Dat goat you saved, dem Mexicans now is gonna eat."

* * *

It was about a ninety-mile drive from our woodless camp on the Rio Grande back up to Alpine, Texas. That drive was through a country in which the kind of trees I had grown up with did not exist. Because plant life there had to adjust to different conditions, all the growing things had developed radically different forms and surprisingly different colors. But as different as they were, they were no less beautiful. And nothing I saw in the Big Bend country was beyond the reach of my art materials. I saw that one could draw Spanish Daggers and cacti with lines and shapes, just as one could draw pecan trees with lines and shapes, and perhaps even big nude women. Maybe I couldn't do it, but I saw that it could be done. I began to have an awesome respect for the pencils, brushes, and colored paints I had brought along.

We had passed right on through Alpine and were driving toward El Paso when a sudden gust of wind hit us and shook the old open touring car violently. The next instant we were in a choking world of dust. The dust-filled wind came upon us like an ambush. We could not see five feet ahead. Traynham stopped the car, and we immediately dived down and put our noses into the crack where the car seat meets the upright seat back. That was the only space where the air was free of dust. We kept our noses glued to that place while the car continued to shake from side to side. Then suddenly the disturbance subsided as abruptly as it had begun. When I sat up I found that Paul Gee and Nellie were still on the floor in front of the back seat. That short interval of time was something to remember. We had now gone through a West Texas dust storm. It may have been nothing more than a

sample of the real thing, since it lasted only a few minutes, but now we knew what it meant to be in such a world of flying dirt.

After living for a time where all the forms we had seen were alive and growing and where there were no houses or buildings in sight, we found it almost frightening to come suddenly into a city. If there had been nothing other than cattle guards to get across in El Paso, Texas, I would have been content for Traynham to continue driving. But because there were now narrow streets, stop signs, buildings, automobiles everywhere, and even people walking, I persuaded him to let me take over.

I then drove right on through that city and did not stop until we came to a place where there was some vacant land with the Rio Grande River on one side and a streetcar track on the other. We could still see the city a short distance away, and if we wanted to go there we had a streetcar that ran right by our door. That place was where we pitched our tent and put our three cots inside.

Traynham and I found that the streetcar really did stop for passengers close by our tent, so, leaving Nellie and Paul Gee in our suburban camp, we boarded one and went to explore the city. As we walked down a busy city street, window-shopping, we came to a music store where there was a display of sheet music in the store window. I could see two Spanish songs among the sheets of music, and it occurred to me that learning Spanish songs might be a good way to begin learning the Spanish language. I went inside and bought the music with its Spanish words for *La Golindrina* and *La Paloma*.

When I came out of the store, I found Traynham arguing with a policeman. I heard Traynham saying, "We are just passing through this place. We are not vagrants, either!" That frightened me, but I went up to them. I thought I had better join in the argument.

The officer looked at my music and asked, "What have you got there?" I told him I had just bought two songs in Spanish. "We are traveling. We are on vacation from Texas A&M until September," I assured him. That seemed to satisfy him, and we were not arrested for vagrancy, although I am sure we looked like tramps. That episode impressed me, and I became convinced that the less I had to do with a city the better off I would be. Nevertheless, we did remain in our suburban camp for three more days.

When Bro Paul learned that the streetcar also went across the bridge and into the Mexican town of Juárez, he asked us if it would be all right for him to go over there.

I said to Paul, "It might be dangerous for you to go over there all alone. You can't speak the language of those Mexicans. You might get lost and never get back here."

Bro Paul said that if he took old Nellie she would know the way back if he got lost. I told him that was nonsense. But anyway he said he wanted to go. "I'se gwine over there, and I'se gwine to learn that language. And then I'll get back on de streetcar and come on home," he said.

So we put Paul Gee on the streetcar bound for Juárez, Mexico, and I was not at all sure I would ever see him again. But after about three hours a streetcar stopped near our tent, and we

146

were relieved to see Bro Paul get off. However, I soon found he had not learned to speak Spanish.

* * *

After three or four days in our suburban tent, we left El Paso and started our return journey home. The first day out of El Paso we came to the Pecos River and made that spot our temporary camp. A short distance away the Pecos River joined the Rio Grande. It fascinated me to see how those two rivers came together.

The Pecos emptied its water into the Rio Grande channel simply because of the direction of its own channel. It could not keep from doing it. But judging from the way its water kept flowing on without mixing with that of the Rio Grande, I got the impression it would have preferred to continue in its own channel all the way to the sea. I supposed that somewhere on down the Rio Grande channel the waters of the two rivers finally mixed, but where we were they remained distinctly apart. So when the three of us decided to swim to the Mexican side, we had to cross through two rivers in one river channel to get there. And we had to do the same when we came back to the United States side.

Despite the different kinds of water, the swim across to Mexico was not difficult. As we sat on the bank on the Mexican side, resting in the sunshine, it did occur to me that we were where we were illegally. One is not supposed to cross into another country just anywhere he might choose. One is supposed to

go to an official crossing place and get checked in. Realizing this, we not only sat on the riverbank very close to the water, but we also kept a sharp eye out for anything that might suggest we make a speedy retreat. It was fortunate that we did, for suddenly we saw bearing down upon us three or four Mexican horsemen who must have been members of *los rurales,* the river guards. The horseman in the lead was whirling his lariat over his head ready to throw as he came charging toward us. The thought that we might be lassoed and marched nude into the nearest Mexican village encouraged us to take to the water very rapidly.

We plunged in and rushed toward the safe side. On my return trip I paid no attention to the different temperatures of the water of the two rivers. When Traynham and I reached a big flat rock on our shore, we pulled ourselves out and sat upon it. We then looked back but could not see Bro Paul. We were looking beyond him. He had arrived with us, but being very tired, he had been unable to pull himself up onto the rock. What I thought was a floating gourd turned out to be Bro Paul's head. Traynham and I reached down into the water and pulled him to safety. He was completely exhausted and might easily have drowned.

Sometime later, after our hair had dried, we discovered it was almost as sticky as honey. The river water had caused the stickiness. There is something in the water at that place that discourages swimming, once you know about it.

We camped on the Pecos River that night. The next morning we walked across the high railroad bridge over the river. The crossties of the railroad track on the bridge were only about

three inches apart, but looking down through them, I saw that we were over a hundred feet up. I was surprised at how frightened Nellie was of that height. She literally crawled on her belly all the way across the bridge and back again.

*　　*　　*

As much as I had always loved my hometown, it now gave me a feeling of sadness to realize that I was going back to it. I believe that was because a beautiful time was ending, and the ending of any pleasant period of my life almost always causes a moment of sadness for me. We repacked our car and put Nellie and Paul Gee in the back seat. I sat next to Traynham, who started driving away from the Pecos River. We had decided to go home by way of Fort Worth and Dallas. We didn't like finding our way through those big cities, but that happened to be where the road would take us. We had found that living where there was a lot of vacant space was much more pleasant and entertaining than living where people had congregated and replaced trees with dead forms of their own making.

As we drove along I said to Traynham, "Don't you just love traveling through all this vast, vacant space?" It seemed to me that the western part of Texas was not only endless but also empty.

"It will fill up soon enough," Traynham replied. "People are far worse than rabbits when it comes to reproducing, and what's more, they want to fill up all the space with their buildings. They would even fill up their streets with buildings if they

could find some other way to get around. Give them time and they will fill up all this country we are driving through with houses and buildings. Do you remember Mr. Bruton in our science class? He said, 'Nature abhors a vacuum.' What he should have said is that people abhor a vacuum. Look at that prairie-dog village we camped in, on the other hand. Those prairie dogs made a big town and there was not a house in sight, and not a smokestack, nor even a standpipe for water."

"Well," I said, "you have to admit they made their houses under the ground. That's why you couldn't see them. If you could have looked under the ground, you might have found it as filled up with their houses and buildings as what we saw in El Paso."

"No," Traynham said, "Prairie dogs don't clutter, and they don't destroy everything around them."

You don't seem to like people very much," I said to Traynham.

"No, I don't like them much, or at least I don't admire them. They also like to kill all living things, including themselves. Every now and then people have to have wars. That is because things get so cluttered up and people get so thick they have to thin things out."

When Traynham said this, I was surprised to find that Bro Paul had been listening to our conversation from the back seat with Nellie. He now leaned forward and said, "Sho nuff! Dey done burned up Richmond in de war. Dem Yankees done caused Richmond to be on fire. We had to get outa dat place in a hurry!" I was amused that Bro Paul had taken us so far back in history.

150

Such depressing talk by Traynham started me thinking about the world as I found it simply by looking at it and trying to paint pictures of it. It now seemed to me to be made up of two parts: space, and objects scattered about here and there in that space. I had found that if I put too many objects in the space on the canvas, the picture would not look at all good. But if I tried to paint only the space, with no objects in it, that didn't look good either.

I had also discovered I could always find something worth painting where people had not tried to arrange the objects in my subject, as they do in parks. Those old shacks I had seen in Villa Acuña looked as though they had grown and had not been made by people at all. I liked to draw them, but I would certainly not have chosen to draw any houses in El Paso. I didn't understand why that was, but I believed I would have to figure out the answer someday.

* * *

It took us two full days to arrive in Fort Worth. We camped for the night shortly before we reached the city, since we knew there would be no place to camp once we got among all the buildings. Later that afternoon, while we were getting settled behind a big billboard, a strange-looking man came up to us. After examining the pictures of the big white swans I had painted on the sides of our car, he informed us that he could eat fire.

"I can eat fire, for one thing," he said, "and I would like to join up with you." He was also looking at Paul Gee and Nellie. "What does your dog do?" he went on to say. It now began to dawn on me that he must be thinking we were a show of some kind.

"What kind of medicines do you sell?" he then asked.

"Listen," I said, "we are not a medicine show. If we were, we would surely want a fire-eater with us. We've just been camping out west and are now returning home." At that, he left us and walked on up the road toward Fort Worth.

The next morning we packed up again and had got almost through Fort Worth when a man in another car drove up beside us and began blowing his horn and waving for us to stop.

"Stop!" I shouted to Traynham. "Let's see what that guy wants."

When we stopped, the fellow got out of his car and came over to us with a big smile. He turned out to be an Aggie I knew. It was old Mockingbird Young from A&M! He had recognized me as we drove by. I was delighted to see him again. It is always good to run into someone like that, suddenly and unexpectedly. Even if you barely knew the person at home or school, he would be someone special in an unusual place. But to meet a fellow Aggie that way was really exciting.

Mockingbird Young could whistle exactly like a mockingbird, only better. A mockingbird would be lucky to get lessons from Mockingbird Young. Often when at a movie on campus, he would suddenly open up in the dark with his beautiful whistling. The Aggies all loved his whistling.

152

After we had told each other good-bye and had started on, I began to wonder what it was that made Aggies have such a warm feeling for each other. I imagined it might be all that pootching we fish had gone through that freshman year.

Old Nellie began acting funny just after we had got through the traffic-filled streets of Dallas and were headed home at last. Bro Paul said, "Dis here dog is gonna have pups right away."

I didn't believe that. I thought it had only been about a month since Nellie had got connected up with that big red and black hound dog in Comstock, Texas. But Bro Paul kept talking to his traveling companion. He was now saying to her, "You sho is gonna give us plenty trouble if you starts having puppies here in dis back seat with me. You jest try to wait till we gits back home."

I told Paul he didn't have to worry, because it was too early, but he was now making Nellie ride as far away from his place on the seat as he could. I looked at Nellie and she appeared unconcerned to me.

I asked Traynham, "How long does it take a dog to have pups? Paul seems to think Nellie is about to give birth any minute now." Traynham said he believed it was six weeks, but he wasn't sure.

We kept on driving south. We knew we only needed about three hours more to reach our hometown. I felt quite sure Nellie was not far enough along for us to worry, but I also imagined that Paul was experienced in such things. Whenever I looked

back, I saw Paul pushing himself as far away from Nellie as he could possibly get. That made me uneasy, to say the least.

When finally I looked ahead and saw the Mexia standpipe in the distance, I felt certain we were going to make it, and that "The Swan" was not going to have to serve as a maternity hospital.

Forty minutes later we drove into the front yard of my family home. The first thing we did was rush Nellie to the backyard where her doghouse was located. She went right into it. Then we went around to the front door, where we were greeted by my parents and my younger sister, Queen.

As Queen gave us a hug she said, "Where have y'all been, anyway?" Then turning to Bro Paul, she repeated her question: "Where have you been with these boys, Bro Paul?"

Paul's answer was, "We has been to de Devil, and I'se been to Mexico three times. But bless God, we is back home at last."

Two weeks later Nellie gave birth to twelve black, half-breed hound dogs. The mighty father of those puppies was still living in Comstock, Texas, as far as we knew.

CHAPTER IX

Back to A&M

When the time came for me to return to college, John Corley announced that he had decided to continue his education and that he was going with me. He suggested we room together. After graduating from high school, John had worked in his father's furniture store for a year. Although that was an education in itself, he felt he should also have some college experience. Traynham Pitts said he believed John wanted to leave town because he had made his girl friend so fat with malted milk shakes.

I would now be a sophomore rooming with a freshman, and John would be the way I was when, as a freshman, I had roomed with Leon Black, a sophomore.

When John and I arrived at College Station, we were assigned to a different company from the one I had been in the year before. We were to be in Company C, which was quartered in Foster Hall. The year before, I had lived in Goodwin Hall, as a member of Company G. Mississippi was also assigned to Company C this time. He would live in Foster Hall, but on a different floor from John and me. Leon Black was in a different company and had landed in some other hall.

I soon received a great shock: I learned that I had been made a corporal. I was in charge of a squad, which is composed of eight men. Mississippi, still a private, was in my squad. John was in some other squad. Leon Black was now chronologically a junior. In terms of courses of study he was still a sophomore, since during his sophomore year he had repeated all the freshman courses he had flunked. He was still a private, too, and that suited him just fine. He told me his ambition was to remain a private even in his senior year, when a student would normally become an officer.

My life at A&M was now very different. Mississippi and I had lost one of our main reasons for being in college, which was to create trouble for sophomores. Instead of having to pootch for sophomores, we were now the ones who were supposed to beat up on the freshmen, and that was something neither of us had the slightest intention of doing. Neither of us had the same motivation as before. We kept on feeling like freshmen even

though we were sophomores. A great part of the fun of being at A&M was gone.

One of my problems now was how to be a corporal. Apparently I had some responsibility for my squad's excellence in drill and in the handling and taking good care of the rifles. However, the drilling instruction was given by the officers and also by the top sergeant. No one in my squad would need any extra help unless it was one private from Louisiana by the name of Analine. He was slow in getting the manual-of-arms drill right. That was the way to get the rifle from the at-ease position back onto the shoulder.

Everything was going smoothly with the military side of my life until one day I was informed that my squad had received the honor of being chosen to act at a military funeral in the nearby town of Bryan, Texas. I was told that once we had arrived at the cemetery by bus, all I had to do was march with my squad up to the grave. After the bugles had sounded taps, the order would be given for my squad to fire over the grave.

None of us had done anything of this sort before, and since Analine had been having difficulty in learning how to get his rifle on his shoulder, I thought I had better talk to him about this so-called detail we were to do. When I found him in his room, I said, "Analine, did you hear that our squad will be going next Sunday to take part in a funeral?"

"Yep," Analine answered, "Fatty told me. I can now do that business of getting my rifle in all those positions."

"That's good," I said, "but the important thing is not to jump the gun, not to fire until the order is given to fire. It will

be, 'Ready, aim,' and then 'fire.' We want to be damn sure not to fire before we hear the order to fire. And another thing we must remember is to aim at a forty-five degree angle. That means halfway straight up. If you shoot low, you might kill somebody."

"Gosh," said Analine, "we wouldn't be killing anybody in a cemetery. They are already dead."

"I know," I said, "but there will be live people there attending the funeral service."

"You better talk to Bob Kellner," Analine warned. "He's the one who might shoot too soon. You know, he's from Mississippi."

Everything went well at the cemetery. It was a sunny afternoon and a small number of people had congregated near the grave. They were standing among the tombstones and bushes. A minister made a talk, and after that a bugler nearby sounded taps. Then to my surprise another bugler, who had been stationed quite a distance away and out of sight, way down at the far end of the cemetery, sounded taps again, like an echo. I knew the time had come for our part. We were standing at attention when the order was given: "Ready! Aim! . . ." But before the word "fire" was heard, some member of my squad shot off his rifle. That created confusion, for the rest of us didn't know whether to wait until we heard the order "fire," or to shoot on our own. We began to make that decision ourselves, with the result that no two rifles fired simultaneously. One gun went off after the other. It was almost as though it had been planned that way. Finally, when I thought the shooting was all over, one more shot rang out. It was Analine. He fired last. It was customary on

158

such occasions for the squad to fire three rounds, but I assume that since eight shots had already rung out separately, the sergeant decided that was enough.

On our way back to college in the bus, I said to my squad, "You guys certainly didn't shine today. I think you have ruined my promising military career."

The only one to speak up was Analine. He said, "It was Bob Kellner who jumped the gun. I know it was. He is from Mississippi, you know."

* * *

In the school year 1919-20, the amount of time taken up by the hazing at A&M, plus the amount given to getting revenge on the sophomores, was almost enough to cause a freshman to flunk all his courses. That was what had happened to Leon Black the year before. Mississippi and I, however, did manage to pull through. I passed all my courses partly because they were not much more than a review of what I had taken in high school.

Now that I was a sophomore, with all that extracurricular activity behind me, there was no apparent reason why I should not make good grades. But I soon learned that was not what was happening.

During my first year in college, I thought I would study chemical engineering. But after fooling with painting and drawing on the Devils River during the summer vacation, I decided to study architecture. I chose that subject because it was as close as I could get to the study of art at A&M. At that time my program

of study included calculus, history of architecture, architectural drawing, freehand drawing, and a course called descriptive geometry.

Calculus, which is widely thought to be difficult, gave me no problem, perhaps because I had taken the correct prerequisites for it. Also, my calculus instructor liked Irish-setter bird dogs. That might have been one reason why I enjoyed his course in mathematics and did well in it. We often discussed our dogs before class.

What was disturbing me now were two courses which ostensibly were very different from each other. They were the history of architecture and descriptive geometry. The history-of-architecture professor was a mousy little man who would never have liked any kind of dog. In fact, I doubt if he even liked the course he was teaching. It certainly wasn't interesting to me. I even developed a prejudice in his class against such things as architraves, stylobates, pediments, Corinthian columns, and capitals.

The course in descriptive geometry was also disagreeable to me. It had that in common with the history of architecture. My dislike of descriptive geometry, however, came about mainly because of the bad grades I received in it. My grades showed clearly that I did not understand that subject. I was never bored by it, though, the way I was by the history of architecture. In fact, I was fascinated all the time I was in that geometry class. The professor, a young man with a small blond mustache, would always draw beautiful straight lines with white chalk all over the blackboard. They were usually in good order, although many

160

times I wanted very much to add a line or two—or to take one out—to make the effect more harmonious.

One day, after the instructor had put a lot of straight lines on the blackboard, he happened to call on me to finish whatever the problem was. I knew I had no idea about the meaning of the lines in terms of descriptive geometry, but I felt sure I knew how to improve upon the way the lines looked. So I thought I might as well do that, since that was all I knew how to do.

While the class and the instructor looked on, I erased one line completely and began adding a line and making another line longer. Then the instructor yelled at me, "Wait a minute! Just what are you doing?"

"Can't you understand it?" I asked.

"I certainly can't," he said, and he immediately called on another student. That student got right up and put back the line I had erased, shortened the one I had made longer, and added a few more. The instructor was now beaming at that student as though he were a genius. But from my point of view he had ruined a pretty, abstract arrangement.

I learned that day that there are two ways of seeing. Clearly the descriptive-geometry instructor never knew that. For him, there was only one way of seeing.

Fortunately there was a course in freehand drawing taught by a man who had only studied art. Perhaps it was because I had already drawn so many chickens and pecan trees that I was able to draw the still-life objects in his class in a way that pleased him. Or maybe the fact that all the other students in his class had never drawn anything at all made me seem, by comparison, better than I really was.

One day the art professor said to me, "Why don't you study art? That is what I studied at the Art Institute of Chicago. I think you would like that."

What he said that day must have settled in among my experiences with descriptive geometry and the history of architecture. It would eventually turn my life around and start me in a different direction.

*　　*　　*

For some time after registration that year, I had no idea where Leon Black was. He, John Corley, and I had been, of course, close friends all through high school, and I had roomed with Leon when I was a freshman. Now I was a sophomore rooming with John, who was a freshman.

One day I learned where Leon was living, so I went looking for him. I found him rooming with a boy by the name of Denning who was from our hometown. This boy was a senior student of architecture, and, to my surprise, I discovered that he was still a private. I recalled how Leon had told me he hoped to remain a private himself. That was one of his ambitions. Most students had the ambition to advance and become officers in their senior year. Leon wasn't that type of person. Neither was I, but without trying, I had already become a corporal.

Now Leon told me he had been thinking things over and that he had something he wanted me to do. "You remember," he began, "you didn't go to the prom last year. I don't want that to happen again. You are going with me to Bryan tomorrow and learn to dance. I don't want you to grow up to be a heathen."

I didn't especially want to learn to dance, but I felt obligated to Leon. I said, "All right, but I doubt if I will ever learn."

Just how he had been able to locate a woman who taught dancing, I don't know. She lived in a residential part of Bryan in a small bungalow. When we arrived at her house, I noticed there was no sign on it to indicate she was a teacher of dancing. We walked up onto her porch, and when Leon knocked on the door this woman opened it and invited us in. I think Leon must have

telephoned her in advance, for she didn't seem at all surprised to see us.

We were in a fairly large front room. The woman put a record on the phonograph, and immediately she and Leon began doing some steps. It was obvious to me that Leon knew how to dance. After all, he had gone to the prom the year before and had invited Mildred, his former girl friend, to come down and be his date. He had broken up with Mildred during high school, but that didn't seem to matter once she had received his invitation. Now, I assumed, he was brushing up on his dance steps.

After the teacher had danced with Leon awhile, showing him certain ways to do it, she took me on. She must have known that with me she was starting from scratch. I think she was probably a physical-education teacher as well as a teacher of dancing, for she said to me, "First, I want to see how you breathe. I want to see if you breathe correctly."

She put her hand on my stomach and told me to inhale in such a way that the air would go into my stomach instead of into my chest. I had not known that was possible. Apparently I had been breathing wrong all my life. She then began teaching me some steps. We tried the waltz and, as I recall, the two-step.

When we left her house, I knew I had not learned a thing that I would be able to use. Those steps were almost as mysterious to me as descriptive geometry. In fact, while I was doing them, moving around the room trying to keep in step with the music, I imagined myself making lines in space. The thought then came to me that perhaps drawing had something in com-

mon with music and dancing. The truth is, though, that I never did learn to dance while I was at A&M, and I never went to the prom.

That did not mean I would never dance, however. I certainly did not know it at the time, but some years later I would be dancing in the dirt, under mango trees, with Indian girls in Mexico.

<center>* * *</center>

As much as I loved A&M, I was beginning to believe I should go to some other place where I could study nothing but art. That belief was not at all based upon any analytical thinking. If I had been capable of thinking in terms of economic advantage, I am sure I would have stayed on and continued with architecture. I was now coming to an important decision entirely by means of intuition. However, as I began to consider taking up the study of art in a serious way, I did remember a story my mother read to me when I was so young I had not yet learned to read. The name of the children's book she read was *The Rambilicus,* and it was about a young man who had the misfortune to become an artist, with the result that he starved to death. But despite that sad prospect for myself if I took up art, I simply *felt* that I should go away and study art. And the only place I knew where I could do that was the Art Institute of Chicago.

I went to see Leon about my idea. I found him lying in the upper deck of his bunk reading a magazine about bass fishing.

"What are you majoring in now?" I asked him.

Leon sat up on his bunk. He hung his legs over the side of the bunk and scratched his head. "You know," he said, "I have been giving profound thought to that matter lately, and I have about decided to go into 'horizontal engineering.'" Of course he was joking. Those lazy students who slept all the time were accused of majoring in horizontal engineering.

"Well," I said, "I am thinking seriously of leaving A&M to go to a place where I can study nothing but art. My freehand-drawing prof tells me the best place for that is the Art Institute of Chicago. What do you think of that idea?"

Leon didn't hesitate to answer. "There are more ways to kill a cat than just by choking him with butter," he said.

I wasn't sure what he meant by that, so I asked him to explain.

"I mean if you can't do a thing one way, you can always do it another way. If you can't learn what you want to learn here at A&M, you should go where you can learn it. But you might freeze to death in Chicago," he added.

Now it seemed to me that I faced two bad prospects: to freeze to death and to starve to death. Nevertheless, what Leon said made me know that I was going to Chicago to study art if I could figure out a way to do it.

166

CHAPTER X

The Art Institute
of Chicago

It was a gray morning in the fall of 1921 when I stood on the train platform of my hometown waiting for the northbound train. It was the kind of morning when voices out-of-doors carry a long way. Wild geese were flying south in V-formation. As I watched them flying high above, I thought to myself, "Those geese probably flew right over Chicago. They wouldn't dare light there, but here I am going to that place." I remember thinking

that, if I could only fly, it might be better to join up with those wild geese than go to Chicago. Maybe I was a goose for wanting to go to art school.

I had checked my trunk to Chicago and was now waiting for a train that would take me as far as Saint Louis where I would change trains for Chicago. My only hand baggage was a large suitcase that held my toothbrush, my shaving outfit, which I had only recently found necessary, and enough clothing to last until my trunk arrived. It seemed to me that my family had turned me loose and put me on my own. Nobody was at the station to see me off. I was beginning an entirely different adventure. I would be living in a big city, which I knew would not be at all like a small town nor like the bank of the Devils River.

The train pulled into the station, and I boarded it with my ticket, my pocketbook, and my big suitcase. The porter took my suitcase and piled it with others in the vestibule between the two coaches. Something told me to keep my eye on that suitcase, and that proved to be fortunate. When the train stopped in a town up the way, I looked out the window and saw that the porter had set my suitcase on the ground outside with some other baggage. There it was, sitting beside the track, and my train was about to pull out. I quickly jumped off the train, and as I grabbed my suitcase the train began to move away. Fortunately the conductor had just got back on, and I was able to climb on after him as the train was gathering speed.

That incident made me doubly careful to watch my suitcase from then on, and it also made me keep my hand on my wallet. Going toward that unknown city of Chicago must have

been for me, at my age, like going to the moon. "Here I am," I reminded myself, "and a short time ago I was in my hometown, and before that, at A&M." As I had that thought, I realized that "here" was everywhere. "Here" is wherever you happen to be. On the train I sat beside a man from my hometown whom I had never known or even seen before. He was quite talkative. He told me he was going to Davenport, Iowa, to have a man sign some papers in connection with an oil lease. Natural gas had been discovered near my hometown years before, and now there were rumors that oil might someday be discovered. I assumed these rumors had something to do with this man's traveling to Davenport, Iowa, to get signatures on a lease. He now began telling me how cold the weather got up north.

"It gets so cold," he began, "that southerners can't stand it. They often freeze to death if they go north. There was one man," he continued, "who got on the train down south and rode clear to Davenport where I am going. A norther had struck that place causing the temperature to drop suddenly to thirty degrees below zero. When the man stepped off the train, he took about twenty steps and then froze stiff, falling to the ground like a big icicle. He was thrown into the furnace, or incinerator. A few minutes later another deceased man was brought in, and when the door to the crematory furnace was opened for this new arrival, a voice was heard coming from somewhere back in the furnace: 'Who is that letting that cold draft in on me? Will you please shut the door?' Apparently it was from that man whom they had just thrown in. They quickly rescued him and found that he was just about thawed out."

"You don't expect me to believe that story, do you?" I asked this traveling companion.

"No, but it will give you an idea of how cold it gets up north," he said.

"Does it get that cold in Chicago?" I asked.

"Colder," he replied. "It is even worse in Chicago, because of the wind."

Although I knew that my trunk contained a heavy wool overcoat which my mother had bought for me, I decided to buy a heavy wool sweater as soon as I reached Chicago.

*　*　*

In the registrar's office of the Art Institute of Chicago, I found many art students not only paying their fees but also being assigned to rooms in nearby locations in the city. One young man in the line introduced himself to me.

"I am John Cross," he said. "I am from Clarksville, Tennessee, and I am here to learn to be a newspaper cartoonist."

I told him my name and that I was from Texas A&M. I said that I was hoping to learn how to draw and paint.

"You had better go into cartooning," he advised me. "If you become a painter, you will starve to death."

Right then we decided to room together. The room assigned to us was on North State Street in an apartment owned by a little black-eyed Irish lady. When she showed us our room, we found that it was on the second floor of a building, right up above the street and above the streetcar track. Every few min-

utes a streetcar would come grinding by, making so much noise I felt sure we would never be able to go to sleep in that room. But we had already paid a month's rent in advance, so we decided to try to stay there at least one month.

That first night the noise was unbearable, but to our surprise, we did not hear any noise the second night, nor thereafter. Apparently one can get accustomed to noise and not notice it at all. However, we did observe later that whenever a friend dropped by to see us, he would invariably say, "How can you stand to live in this noisy place?"

Johnny Cross and I were in several of the same classes at school, one of which was life drawing. The first morning I entered that class I was surprised, but also delighted, to find a pretty, fat nude woman seated on the model stand for us to draw. I knew Traynham Pitts would approve of this situation, for he had wanted me to paint a fat nude woman over one of those bars in Villa Acuña, Mexico. Now I hoped to learn how to do that.

Everybody was drawing with black charcoal on snow-white paper attached with thumbtacks to a board. I almost wished I could draw with white chalk on a piece of black paper, since I had recently looked at so many white lines in my descriptive geometry class at A&M.

As something to draw with, charcoal was new to me. A big Canadian by the name of George Allen was sitting next to me in the class, so I said to him, "I am a beginner at this. How do you go about it?"

I don't believe he **had** been in the art school long, but he was eager to help me. "**You do it this way**," he said. "You start at the head and you work **down**. And when you get all the lines in, you start shading. That is the best part of the process. You put on shading, starting at the line and shading gradually out from it. That will make a round effect. When you have done this all over, you begin to rub it, and the more you rub the better it will look. I found that out myself. Nobody told me, but you will see it is true." He went on to say that at the school store I could buy a thing called a "stump" which I should use for rubbing instead of using my fingers.

This was the second art lesson I had received in the last year, and the first one in a real art school. The other lesson was on the Devils River, when Paul Gee kept throwing dirty, soapy dishwater on my canvas that was propped up against the trunk of a pecan tree. There had been no doubt that the soapy dishwater had made my painting look better, but I had not yet been able to figure out why that was so. As for the continuous rubbing of the charcoal, I had real doubts about the merits of that.

In the life-drawing class, we had very little professional instruction. We were provided with a fat nude woman to look at and try to draw. I supposed the school authorities thought we should not expect more. The room was crowded with art students, all staring at the nude model and silently trying to draw what they believed they were seeing.

Not far from me, on a tall stool, sat the most beautiful girl I think I had ever seen. She was fully clothed, of course, and wore, in addition, a long pink smock to keep her dress from being

soiled by the charcoal. After I discovered her, I found it difficult to look at the nude woman on the model stand. I much preferred looking at that dainty, beautiful girl.

Johnny Cross had also seen her. When the class was over and we were going out of the room, I said to Johnny, "Did you happen to notice that girl in the pink smock, the one on the high stool?"

"I sure did," he answered. "She is so pretty and so dainty no man will ever marry her."

"I'd like to know why?" I answered, for she was so beautiful I felt sure men would be willing to fight over possession of her.

"Well, some man might marry her," he conceded, "but he would never sleep with her. He would just want her around to look at from a distance."

It seemed to me I was hearing a great deal of unusual and surprising information in this art school. I knew I would have to think about it carefully before I could accept any of it as true.

* * *

Our room above the streetcar track on State Street was in walking distance of the Art Institute. On our walks to and from school we always passed by a pet shop. We were fascinated by the dogs, cats, and birds we would see through the window of that store. One day there appeared in the window a little black monkey with a long tail and a white face. A sign next to him stated his price, and I was delighted to see that I could afford to

buy him. So I went into the store and bought the monkey. He was placed in a box for me, and I went on to our room, very proud to actually be the owner of a real monkey. When I arrived at our place I found Johnny reading an art magazine.

"You will be surprised when I show you what I have in this box," I said. "I thought we needed another roommate. Wait till I open this box."

Johnny was wondering what I had in the box. When I opened it, out came the lively monkey. The first thing he did was scamper up to the ceiling of our room, going up the white curtains that hung on each side of our window. I had not even noticed those curtains before. The monkey must have been frightened, for he stayed up there, looking down at us and chattering a long time. I started calling him "Coco," and I kept begging him to come down. Finally he must have responded to the kindness in my voice, for he descended and jumped upon my shoulder. We became friends. He also became friendly with Johnny, who was as delighted with our new roommate as I was.

But as fond as we were of that monkey, we soon learned that there were lots of problems we had not foreseen in keeping a monkey in a small room with us. After a couple of days I took the box with Coco in it and shipped it to my sister Queen in Mexia, Texas.

I soon received a letter from her saying the monkey had arrived safely, and that everyone was in love with him, especially Paul Gee. Queen said Coco seemed to love Paul, too. Coco would mind him; he would do whatever Brother Paul told him to

do. I was pleased to receive that news, for I had not felt certain my family would like to have a monkey.

Several weeks later, however, I received another letter from Queen in which she said my father had given Coco to some passing Gypsies. She said the monkey would go into my father's henhouse and pick up a hen egg in each hand. When my father would scold him and tell him to put down the eggs, Coco would throw them at him instead and break them. But what really annoyed my father and caused him to give Coco away was something else. Queen said that one day Bro Paul let Coco loose into the dining room during dinner. Coco immediately jumped onto the dining-room table and dragged his tail right through the butter dish. She said she was sure that was when my father made up his mind. She added that Paul was broken-hearted when he learned that Coco had gone away with the Gypsies.

*　　*　　*

Another class I was taking in the art school was still-life painting. In that class the students arranged inanimate objects as subject matter. At A&M I had taken still-life drawing where we used pencils. Here at the Art Institute I would be using oil paints, a medium I knew a little about because of the painting I had done on the Devils River and in the Big Bend country of West Texas.

After I had arranged my objects that first day, in a kind of three-cornered box provided by the school, I proceeded to draw the subject with lines just as I would have done at A&M. But

before I had begun to use my oil paints, an instructor came along. He pulled up a stool and sat beside me. His name was Mr. Poole, and he looked a little sickly to me. I had been told that he was recovering from lead poisoning caused by his habit of drawing his loaded watercolor brush through his lips to get a good point on it. He looked at my sketch, and I was pleased that he did not appear to find fault with it.

"Now," he said, "I want you to *wish* your paints onto the canvas. Just wish them on. Look at your subject and then just wish the colors onto the canvas. Do you understand?"

I did not understand at all, but I thought I had better keep quiet. I did not want this class to turn into another class in descriptive geometry. The instructor must have thought I understood perfectly, for he then got up and walked away.

The advice he gave me really slowed me down. If he had not come along, I would have started right in painting. Now I had to wait and try to figure out how I could get my colors onto the canvas just by wishing they were there. I did just what he told me to do. I looked at my subject, and I wished hard that my colors would get themselves onto my painting. I did that because I had paid for his instruction. But since nothing happened, I decided to go to work on my own.

As I now think back on that still-life painting class, I believe its real value was twofold. In "looking at the subject," I was learning to see objects as ends in themselves, instead of seeing them the way I had formerly assumed them to be. It is amazing how different everything appears when a person looks at objects as though he had never, ever, seen them before. In

that way the ordinary suddenly becomes extraordinary and charged with excitement, regardless of how commonplace it may have been before.

The other value of that class came from learning the true character of the oil paints, by looking at them the same way and using them. Colors which formerly were real only as name—such as blue, red, and yellow—now became real in the way they felt. Looking at them in this way, one discovers that certain colors seem to hit the eye harder than others. Some feel heavy, while others feel light in weight. Some feel cool, and others feel warm. I learned in that class that we live in two entirely different worlds, and that it is possible to move from one of those worlds into the other at will.

Although I was busy working in my art classes on weekdays, when I learned that an artist by the name of Bill Owen was teaching a Sunday class in outdoor painting, I joined that class also. I got up early the next Sunday morning and went to the corner of State and Randolph Streets. I had with me a small canvas, my paint box, my easel, and my stool. At that corner I joined the members of the outdoor painting class. I went with those art students on the streetcar west to the very end of the line. From that point we walked about a mile until we were in a beautiful, wooded country. I was surprised that it was possible to get so quickly out of the big city and into land that looked as though it had never been touched by man. Many of the trees still had their fall colors. Here and there were open areas covered with dry stretches of grass.

I was now wondering if my experience in painting West Texas pecan trees would help me paint these trees which looked as though they might be post oaks, elms, and a tree which back home we called a blackjack. All the students scattered about, set up their easels, and got to work, as though they were professional landscape painters doing what they knew how to do.

After I had set up my easel and started my painting, I knew I was doing only what I had done before without ever having had an instructor, so I thought it might be helpful to look at what these experienced students were doing. I went over to where a student was being helped by the instructor. I had met this student before, and he had immediately started calling me "Tex."

This young man had a large canvas on his easel. It was at least three times larger than any I had ever attempted to use. Already his canvas was divided into about five large shapes, which were thinly covered with colors. Apparently he had mixed his colors with so much turpentine that they were transparent, like watercolors. As I watched him I noticed that he was now applying opaque color over these shapes. The instructor even took this student's brush and added more opaque spots. I also noticed that they were both looking at the landscape subject. It was clear to me that they were seeing, or thought they were seeing, in their subject the same colors they were putting on the canvas. When the instructor saw I was watching, he suddenly turned to me and began to explain. I must have looked as though I did not understand at all.

"You know," he said, "it is necessary to see the subject as though you are looking at it through a window glass, and you must pretend that what you are seeing is really on the glass. In that way the subject becomes flat, for if it weren't flat it could not be seen as being on the flat window glass. Once you can see your subject as flat, you can handle it, because your canvas is also flat. That was the way Monet saw, and that was the way Impressionism was born."

I must have looked very appreciative, for he continued giving me a private lesson. "After you see your subject as flat," he continued, "you must look at all of it at once. Then, while holding all of it in mind, while being aware of all of it at the same time, you must notice the few big shapes that make it up. They will just naturally reveal themselves to you if you keep all of the subject in mind. There won't be over five of those shapes, because that is about all your mind can take in at once. You must understand that in this way of seeing there are two things involved: your mind and your subject. Painting, to be meaning-ful, must be a cooperation between those two."

I thought I understood pretty well what he had said, so I returned to my easel and tried to put it into practice. I found it very difficult to see my subject as flat. I knew it wasn't flat, even though I could understand that the image of it must be flat. I thought to myself that I should buy a flat piece of glass to look through, and that then maybe the subject out in front of me would settle onto the glass.

While I was busy trying to get all those trees, the sky, and the fields to become flat, a loud noise broke out where several

180

students were painting about a hundred yards from me. There was so much laughing and shouting going on that I thought I had better go over and see what was happening.

"I'm going to throw all this damn stuff over in that ditch!" a student was saying. Everybody around him was still laughing. When this student turned, I saw that the rear part of his pants was covered with all the colors of the rainbow. Then I saw his big palette on a stool. For some reason he had sat right on his palette, which had all his colors scattered over it. Clearly he would never be able to get that thick oil paint off his backside. The best he could do would be to get it rubbed off to where it would not ruin the streetcar seat when we returned to the city.

This art student was extremely upset. He now turned to the others and said, "Damn it to hell, I'm giving all my art stuff to anybody who wants it." I looked at his equipment and saw that it was the best. He even had Windsor-Newton tubes of paint, the most expensive you could buy. His easel, his stool, and his sturdy paint box were all expensive.

"Who wants this damn stuff?" he kept saying.

Nobody would take it, for we all knew if it were taken, then it would be difficult for him to ask for it back after he had cooled off. But he kept this up so long that finally one student came up to him and said, "If you really are going to give it away, then I'll take it."

I think the other students didn't like that boy for doing that, but he began gathering it all together as though he now owned it. Some of us got rags and turpentine and tried to get the paint off the angry student's pants, but the paint was only

spread over a wider area. However, we did manage to get it to where he would be permitted to ride on the streetcar.

When we went back to the city in the late afternoon, I felt I had learned a lot. The next day at school I did not see the boy who had sat on his palette. I was told that he had quit the art school and had decided not to be an artist. That seemed to me a pity. I thought the world might have lost a great painter, perhaps another Van Gogh.

* * *

While I was at the Art Institute of Chicago, most of the boys were there "on a shoestring." The girls, however, seemed to be from wealthy families. Some of those girls would be driven to school by chauffeurs, in big cars, and they would step out of the cars wearing fur coats. The boys, on the other hand, walked to school or rode the bus, and some wore patches on their clothes. Yet I noticed that the girls seemed to like the boys, as if they, also, were wealthy. The girls would give parties in their homes to which the boys were invited, and at Thanksgiving and Christmas they would invite the poor boys to dinner.

There was one very vivacious and pretty blond girl who invited me and some of the boys I knew to a dinner in a home on the south side of Chicago, where Johnny Cross and I also now lived. We had finally left the little room over the streetcar tracks on the near north side. The home this girl lived in was not her own. I believe she may have been living with a relative while going to art school.

The night we went to her party, it was cold. To get to her house Johnny and I had to walk a couple of blocks from the streetcar over a sidewalk from which the snow had been shoveled. The snow had been piled up so that it formed a wall on each side of the sidewalk about four or five feet high. I remember how beautiful it was walking silently through that snow tunnel in the moonlight. I felt that we were in an unreal and enchanted world.

We arrived at the handsome home and were received in a large, elegant, and warm front room. There were several girls present in addition to the pretty, blond girl who had invited us. After we had been in the room an hour or so, this girl asked if any of us wanted to use the bathroom. That was a real shock to me. I realized that where I came from no girl would ever say a thing like that, and I certainly would have let my eyeteeth float before I would have asked where the bathroom was located. I figured that Yankee girls were different in that way, and when I thought about it, I decided it was sensible.

That big Canadian who had told me how to rub my charcoal drawing was present, and so were two other boys from art school. One of them was a very friendly boy named Lowell Houser. The other was his roommate, Tony Carbon.

After a while we all went into the dining room and sat down to dinner at one long table. A matronly woman sat at one end. She was Mrs. Billingsby, our hostess. We were having a merry time talking and singing, even though we had had nothing alcoholic to drink. It had never occurred to any of us that liquor was called for. The big Canadian started singing a song

that began with these words: "Where do the flies go in the wintertime?" After that we all sang,

> *Mademoiselle* from Armentieres,
> *Parlez vous?*
> *Mademoiselle* from Armentieres,
> *Parlez vous?*
> *Mademoiselle* from Armentieres,
> She hasn't been kissed for forty years.
> Hinky dinky, *parlez vous.*

Then George Allen, the big Canadian, began telling a joke. But after almost every sentence he would burp. He would then turn toward the hostess and say, "Excuse me, Mrs. Billingsby." A few seconds later he would burp again and say the same thing. Always he would look at the hostess and say, "Excuse me, Mrs. Billingsby." Apparently he didn't think it was necessary to be excused by anyone but Mrs. Billingsby. We all just sat there and hoped that she would excuse him. I was hoping she would finally say, "To hell with you. I won't excuse you if you do that once more."

Later in the evening, as we were leaving that party and moving through the front door, the pretty girl who had invited us came running toward us. To my complete surprise she grabbed me and planted a kiss right on my lips. She then ran back to the dining room. That kiss she planted really did seem to grow. I was disturbed by it for several days.

* * *

One day an art student who looked quite poverty-stricken came to me and asked if I would like to make some money. "I've got a contract from a clothing company to paint about two hundred landscapes," he said. "They're going to give one genuine oil painting away with each suit sold. But I only have a week to do them if I am to get paid."

He went on to say that he would supply the paint, the brushes, and the small boards, and that I would get two cents a painting. That meant I would make four dollars. I wasn't hard up for money, but I thought this might be an interesting thing to do. I said, "Sure, I'll help if I can. When do we do this painting of landscapes?"

"You come to this address tomorrow at 3:00 P.M." he told me. "Everything will be set up."

The next day I went to that address and found that it was on the second floor of an old-looking building. I entered a large, completely empty room, and I noticed a narrow shelf that ran entirely around the big room. Lined up on the shelf were dozens and dozens of small rectangular boards, one right next to the other. On the floor I saw about five buckets of oil paint. There were four other students in the room, including the one who had the contract. This student showed us a simple line drawing of a landscape the same size as that of all the boards.

"I will go first," he said, "and draw in the lines. Each of you in turn can follow me with your paint bucket and brush."

I had been given the bucket of sky color, so I went right after the master drawer. After me came the student with paint for the opaque white clouds, and after him came the boy with the bucket of earth or land color. The last boy had two buckets. One was for tree trunks and limbs and the other for green leaves. Painting in this way reminded me of a kind of song I believe is called a "round." One person sings the first sentence and then the next person starts singing that same sentence. When he finishes the first sentence, the next person starts. Then all sing right on through to the end. One song of that kind is *Three Blind Mice,* and another is called *Old Tom is Cast.* It has these words:

> Old Tom is cast,
> And Christ Church bells ring
> One, two, three, four, five . . . six
> And Tom comes last.

When we had gone all around the big room with our buckets of paint, we looked back and saw that we had created about two hundred genuine oil paintings. But I doubted if they looked as good as a musical round sounds, even though I was beginning to believe there was a real connection between music and painting.

* * *

During my art-school days in Chicago I was involved in quite a lot of school social life. It did not interfere with my art studies, however, because I usually managed to get back early to my room. Johnny Cross and I were often invited by girls to parties in their homes.

One night we went to a party in Evanston at the home of a girl named Pauline Graf. That night, everyone got so interested in a game we were playing that the party did not break up until quite late. Since Johnny and I were now living on the south side of Chicago, we would have a long trip home. The main reason we had moved to the south side from our State Street address was that Pauline's father had insisted upon it. He had told us we were in great danger where we were living. He had said that we were surrounded by members of the Mafia whose boss was a notorious individual by the name of Al Capone. Partly because of this information Johnny and I had moved to a place on the south side where Lowell Houser and his roommate were living.

When we left Pauline's house late that night, we had with us a refined type of boy whose name was Bryan Atherford. He was tall and he dressed very neatly. He had a good-looking face; there was nothing wrong with it in any way. But going home on the "L" that night, I looked at Bryan seated across from me and noticed that he was extremely cross-eyed. He had not been cross-eyed before. I punched Johnny, who was seated next to me, and whispered, "Take a look at Bryan and tell me what you notice."

Johnny looked at him and saw how cross-eyed he was. Johnny said, "Jesus, Bryan, what got wrong with your eyes?" I was embarrassed that he had put the question so bluntly.

Bryan said, "Oh, this always happens to me when I stay up late. When my eyes get tired they always tend to cross a bit."

"Cross a bit!" Johnny said. "You are downright tangle-eyed!"

Not long after that late ride home, Bryan invited us to a stag party where the strongest drink served was lemonade. At that party he announced to us that he would soon be leaving art school. We regretted that, because we really liked Bryan.

"I am extremely happy to announce to you fellows," he said, "that I have been highly honored. I have been chosen to begin studies for the Episcopal ministry."

We knew that congratulations and cheers were now in order, but I was secretly thinking I would not want that to happen to me. I realized that the ministry was a noble profession, but I was quite sure I would never be "called" to preach the Gospel.

Oil Boom in Mexia

Shortly before Christmas during my second year in art school, I decided it would be better not to continue living in the cold, windy city of Chicago. The time I had spent at the Art Institute had been both pleasant and profitable. While I was attending that school, I had only to walk upstairs to study and enjoy great masterpieces of art. The thought of going where there might not be such an opportunity disturbed me. However, when one comes down with a strep throat in a cold place, he just naturally starts thinking about a warm place.

One day as I was thumbing through an art magazine, I came upon a little art-school advertisement toward the back, which said, "Come to sunny San Diego, where the sun shines the whole year round." I thought to myself, "That must be the place for me."

Now that I think about that little ad in the back of that art magazine, I wonder seriously if what we do and where we go in this world has not been planned for us in advance. Why did the Episcopal Church suddenly select Bryan for the ministry when he was so content to be studying art? And why did that class in descriptive geometry confound me just at the time when my freehand-drawing instructor at A&M was telling me about the wonderful art school in Chicago? My decision—which may have been something else—to go to San Diego, California, put me on a track that I would follow the rest of my life.

I returned to my hometown during Christmas vacation, determined to continue on to San Diego. When I arrived I received a great surprise. The town I had left in the fall of 1921 had had a population of less than three thousand, and now, a little over a year later, it had more than fifty thousand people living in it. And they all seemed to have gone wild. My hometown was in the midst of an oil boom. It had changed from a quiet community of Methodist and Baptist church-going people to a place where gambling and prostitution were out of control. Eventually the town would be placed under martial law.

It had taken over two days to go by train from Chicago to my hometown in Texas. When I arrived there and started walking up the street from the railroad station, I was surprised by

the great crowd of people at the intersection of Commerce and Sherman Streets. To escape the pushing and shoving crowd, I stepped into a dry goods store on Commerce Street. A woman clerk came up to me immediately and said, "What can I do for you?"

"I only came in to get out of that big crowd," I replied. "What is going on out there, anyway?"

She seemed surprised I didn't know. She said, "Didn't you notice the raised platform with the automobile on it? They are giving away that automobile to whoever has the lucky number. If you don't have a ticket, you had better buy something right here and get one. You get a ticket for each dollar you spend."

I looked around and saw a rack full of neckties. I noticed they were all priced at one dollar each. "Then let me have a necktie," I told the woman.

I took the tie, and she gave me a ticket with a number on it. I then walked out the door and started making my way into the dense crowd. Looking up at the raised platform, I saw not only the car but also two or three people up there, and one of them was my old friend John Corley. I saw that John was reaching down into a barrel. He pulled out a ticket, looked at it, and handed it to a man who had a megaphone. This man read the number and called it out on his long megaphone. I looked at my ticket and almost passed out. I had that number. I raised my arms and yelled, "Here it is!" I then worked my way through the crowd to the platform and handed in my ticket.

John and the other man looked at my ticket, and John said, "By golly, Jackson, it's all yours."

That was the first time I had ever won anything. I was told I could either take the car or I could drive it one block to the Overland car dealer and turn it in for nine hundred dollars. I did the latter. Now, with a new pile of money, I felt ready to take off for California.

* * *

That same day, after dark, John drove over to my house to get me. "Come on," he said, "I want to show you Mexia."

John started driving through the crowded, muddy streets until he got to the Teague Pike. That was the same road Henry Spillers had traveled with his gun held against the head of the black driver. I was soon to learn that whereas Henry Spillers was one of the few gun-toting persons in our town in those early days, carrying a gun had now become the ordinary thing to do.

About three miles out of town, John turned off the pike and entered a field full of automobiles. They were parked all around a low wooden structure. I could hear lots of noise and music coming from that building.

"This is just one place I want to show you," John said, as we walked to the entrance of the low building. It seemed to be shaking with all the noise and music inside.

To my surprise, as we entered John pulled from under his coat a big pistol and checked it at the entrance desk. Since I made no move to turn in a gun, a big fellow standing at the desk began to frisk me.

"I don't have a gun!" I said. "I just arrived here from Chicago."

That must have made him suspicious. I suppose he was thinking of Al Capone, for he then frisked me again. John told him I was an old friend, so we were allowed to pass.

The first room we entered was a kind of entertainment place. A big scantily dressed woman, very sexy, was dancing in the middle of the floor. She was surrounded on all sides by men. one fellow I recognized had been a deacon in the Baptist church when I lived in Mexia. He was now tossing silver dollars at the feet of the dancer. He was excited, and he kept saying, "That's the gal! Shake it, baby!" Then out would go another silver dollar to her feet. There was a lot of smoke in the room and most of the men seemed quite drunk, despite the fact that it was the time of national Prohibition. In another room all was relatively silent. People were at gambling tables. There was a table for roulette,

one for blackjack, and one for cards. Also there was a table for crap shooting. These tables were surrounded by men. A girl, almost nude, was busy delivering drinks on a tray.

The next day John took me to see other parts of my new hometown. To the west it had expanded in all directions. The buildings appeared to be temporary, for they were all of wood and were shabbily built. These shacks were everywhere. Also, there were many plank sidewalks that made it possible to avoid the black mud in the streets. The sidewalks were crowded with people, and wagons loaded with oil-well material were being pulled through the streets by horses and mules. In one part of this shambles, I saw several dignified-looking men walking among the crowd. They stood out from the others partly because they were well dressed and neat looking. One of them looked familiar to me, and I was about to speak to John about them when he said, "Look at those guys over there. Do you recognize them?"

"One of them looks familiar to me. Who are they?" I asked.

"The one in front is General John J. Pershing, the man who used to chase Pancho Villa in Mexico," he said. "I think the one behind is Mr. Charles Dawes. Since the oil boom, it is common to see nationally known people on our streets."

At that moment I noticed a black man I had known before. He used to bring all his cotton to be ginned at my father's cotton gin, and he almost always wore a suit of clothes made of sample patches. He had on such a suit now. I said to John, "Will you let me out for just a minute? I want to speak to that fellow in the patch suit."

John stopped the car and I managed to get across the muddy street where the man was moving through the crowd. When I spoke to him, he seemed very happy to see me. I told him I had been away to school and that when I saw him, I just wanted to say hello.

This friendly black man informed me that he had four oil gushers on his land now, and that if I ever needed any money he would be glad to let me have all I wanted. "I can't even count my money, it keeps coming in so fast," he said.

I appreciated his kind offer, and I knew he meant it. I had long ago learned that the black farmers around Mexia were the finest kind of people. I was delighted that they were now profiting from the oil boom.

When I got back into the car, John said, "There is one other thing I wanted to tell you about those celebrities we saw back there. They are not here for entertainment. They are here to get in on the moneymaking. The town is so crowded they will probably have to sleep tonight in one of those shacks you saw."

"John," I said, "I notice you are not smoking. I thought you would at least be smoking a pipe." He knew immediately what I was referring to.

"You know," he said, "I only use tobacco as wadding in my shotgun. I learned how to shoot smoking pipes out the end of my shotgun down on the Focke farm. I learned on that camp that that's the best way to use tobacco."

"John," I continued, "what about all our old girl friends? I wonder if we could drop by and say hello to Beth and Mildred?"

John shook his head. "I guess this place got too bad for them. Beth is living in Florida, I think, and Mildred's dad has so many oil wells on his farm that she may be in Europe. She wouldn't think of living in this mud."

I had now seen enough to realize that the hometown I had known was no more. It had been invaded as if by a Comanche Indian raid. The Comanches, however, destroyed towns by burning the buildings and by killing all the inhabitants. My hometown was ruined by the buildings and shacks that had sprung up in every available space, both in town and on out in the countryside, and by the crowds of wild people who had flooded in with the hope of making lots of money from oil, gambling, prostitution, or robbery.

It seemed to me that what had been my beautiful small town was now despoiled, maybe even murdered. As I looked around I doubted if it could ever be resurrected. I thought that from now on it could only live in the memories of those who had known it before the oil boom struck it. I knew some people would say that at last the town had come alive. But for me it had been ruined and, I suspected, by greed.

I hated to think of my family living in a place that had gone mad even though my own mother now had one of those oil gushers. I hoped they would live through it and eventually see to it that the town would be cleaned up and made beautiful again. I doubted, however, that even if it someday returned to normal, it would ever again be what it had been before.

196

It was with a slight feeling of confusion that I caught a train for California. I felt that I was abruptly putting my past behind me, literally cutting it apart from my present, and that now I was facing all that was left: an unknown future.

CHAPTER XII

California

In the early spring of 1923, San Diego, California, struck me as a place of brilliantly colored flowers, extremely tall trees, bright warm sunshine, and cool blue shadows. After I had traveled two days through gray desert spaces, my sudden arrival in that small, clean city was a shockingly pleasant surprise. I could never have imagined that such a place could exist. If anything as devastating as an oil boom had ever struck this town, it had certainly left no scars.

My train had just emerged from mountains that looked as though they had exploded. Rocks the size of buildings seemed to have been thrown in all directions. The train had then pulled into a railroad station unlike any I had ever seen. Clearly this station had been designed to be admired first, and only thereafter seen as a terminal. The sun was about ready to set, and everything was flooded with a warm, friendly light.

My first practical thought was to find a place to pass the night. With my suitcase in hand I started walking toward the heart of the city on a wide street called Broadway. Soon I came to a large building with a big vertical sign that said "San Diego Hotel." I decided that would be where I would spend my first night in this magical city. But it was not for me to decide. I was told at the desk that the hotel was full because of the horse races in Tijuana. Not one room was available. As I stood there wondering where this town or city of Tijuana could be, the desk clerk began calling around and soon found a room for me in the Sandford Hotel on Fifth Avenue, not far away. I then walked to that place and was pleased with the room assigned to me.

The next day was Sunday. Everything seemed to be closed. By walking through the streets, I finally found open, of all things for that day and that time of day, a vaudeville show. To kill time I bought a ticket and entered. Apparently the pretty dancing girls must have been at the point of terminating their act, for as I sat down they all ran off the stage. Immediately a curtain went up revealing a clown among several stacks of different kinds of groceries. The lights in the audience went on, and the clown began calling out numbers. I saw that the people in

the audience were looking at the numbers on their ticket stubs. One person won a big ham. The clown then picked up a tall red bucket of coffee.

"Here we have a five-pound bucket of Arbuckle Brothers coffee," he announced. Then he called out a number. I looked at my ticket stub, which I happened to have saved, and saw that I was now about to become the owner of a five-pound can of coffee. That was quite a comedown from an Overland touring car, but it did seem to prove that my luck was still with me.

Walking north up Fifth Avenue for about a mile, carrying my big bucket of coffee, I arrived at a large Victorian-style house. It was situated just off Fifth Avenue at the corner of Fourth and Maple. A sign in one of its windows announced, "Room for Rent." I walked up the steps and knocked on the fancy front door. It opened immediately, and in front of me stood a large-boned, stern-looking woman.

"I noticed the sign saying you have a room for rent," I said. "My name is Everett Jackson. I have just arrived from Texas."

"My name is Mrs. Leach," she answered. "Yes, I have one nice upstairs room, with a bay window, on the Fourth Avenue side. Would you care to see it?"

"I would love to see it," I said. And I added, "Would you by chance like to have a five-pound can of Arbuckle Brothers coffee? I would like to give it to you if you happen to be a coffee drinker."

Mrs. Leach was delighted to accept the big can of coffee. She took it from me, and I entered the hallway of the house. Together we began climbing a stairway to the second floor. She showed me into a large room with a big bay window overlooking

a street. I noticed that across that street was a red brick wall with green leaves and red flowers all along it. In contrast to the rooms I had inhabited in Chicago, this one was truly elegant.

While I was admiring the room, Mrs. Leach said, "The rent is thirty dollars a month. And if you like you can have your meals with Mrs. Brauner who runs a boardinghouse just behind this house."

What a difference from an oil-boom town, I was thinking. A cot in a hallway in my hometown was then priced at fifty dollars a night, "take it or leave it."

I told Mrs. Leach I was delighted with the room, and I paid her right then with three ten-dollar bills for the first month's rent. With the bucket of coffee still in her arms, she was most cordial, and I knew I would be welcome living in that big old house.

* * *

My room at the corner of Fourth and Maple was not far from the art school. To get to the school, I had to go south one block to Laurel Street and then turn east on Laurel and walk through a beautiful park and over a high bridge. The bridge spanned a wide canyon filled with green trees and shrubs. It was very high, so that you looked down onto the tops of the trees. After crossing the bridge, I noticed that flowers seemed to be everywhere.

When I arrived at the school, which was located in one of the old buildings left over from the 1915 Exposition, I signed up

202

for life drawing, still-life painting, and landscape painting. Since the still-life painting class was to meet that morning, I decided to attend it even though I had not yet acquired any art materials. I was surprised to find that the class had only two members and that I was one of them. The other member was a young married woman, a beautiful brunette by the name of Katharine Kahle. She told me we were the only members of the class because we were the only advanced students in the school. When I was at the Art Institute I was not an advanced student, but out here I was advanced. "That is what distance can do for you," I thought. I felt sure that when this other member of the class saw what I would be painting, she would know that she was the only advanced student in the school.

I think my favorite class was landscape painting, partly because it was held out-of-doors, but also because it was taught by such a charming person. The instructor was an artist named Otto Schneider. If I had been asked at that time how old Schneider was, I would have said, "middle-aged." He was about forty-five. He had a very red face, probably because he was always painting outside in the sunlight. He was truly a jolly, happy fellow, full of enthusiasm. He would say, "Look at the light! Paint the light! You have to paint it fast because it will go away! It is changing all the time! You have to catch it while it is there. Look at that doggone light on that tree trunk over there! I tell you, it is just wonderful, but you've got to catch it. You have to work fast!"

I would look, and my eyes would be opened by his enthusiasm. I think I learned right there that the way we see things

depends on how fascinated we are while we are looking, and also perhaps on how happy we are at the time.

One day we were all painting down at the waterfront, where there were lots of little boats out on the water and some drawn up on the beach. Suddenly I discovered on my own that I could look at one boat at a time, or I could look at all of them at once including the space that was around them. From the moment I started seeing everything at once, I was able to start working on my painting with the feeling that I knew what I was doing.

In Mr. Schneider's class, there were several older women and two other middle-aged men like Mr. Schneider. Those two seemed to be more interested in talking to each other than in painting. They were often deeply engaged in conversation. One day I decided to listen and find what they were talking about. I thought that maybe I might pick up some valuable information about painting, for I had noticed they were always talking about art.

"You just can't do it here!" one of them was saying. "You have to make a clean break; you have to get way away."

The other man said, "I don't see why. There is beauty here, too."

"Yes, but that's not it," the first man said. "You are all tied up and don't know it! You have to get away from everybody and everything you know, get into a foreign environment. Gauguin did that. Otherwise you will wind up being just another mediocre painter."

204

I noticed they never seemed to get much done in the class.

I thought to myself, "I have certainly gone a long way from my hometown. Maybe that will help me learn to paint."

When I went back to the big old house on Fourth Avenue that afternoon, I found two boys about my age playing catch at the side of the house next door. It also was a Victorian-style house, even bigger than the one where I was living.

One of the boys said, "I have to go now. Maybe that guy will play with you." The other boy then asked me if I would like to play catch.

I said, "Sure."

We told each other our names. His was Odell Lovell. He lived in that big house, along with lots of people I never did meet. We played catch until nearly dark. And after that we played catch often at the same place.

One day Mr. Schneider took our painting class to an old abandoned Indian village. It had been constructed, like the buildings in the park, for the 1915 exposition. I figured that expositions were held in cities to cause those cities to grow bigger. We went to this old Navajo village to paint. A very pretty Mexican girl had joined our class. I decided to try to get to know her because Mexicans had always interested me, and because they especially interested me now that I had been to Villa Acuña with Traynham Pitts and Paul Gee.

As we were walking together through that old Indian village looking for a view to paint, she suddenly stopped, put down her art things, and said, *"Aqui paro yo."*

"What does that mean?" I asked.

"That means, 'I stop here,'" she said.

I knew I was picking up some more words in Spanish. "Where do you come from?" I asked her.

"I come from Tijuana," she said. "That's where I live. That's where my home is." It was from this pretty Mexican girl that I learned that the town of Tijuana was in Mexico and only fourteen miles away.

* * *

My brother Ben used to sing a song with these words:

> There is a boardinghouse
> Far, far away,
> Where they serve fried ham and eggs
> Three times a day.
> Oh, how those boarders laugh and yell
> When they hear the dinner bell
> Three times a day.

From my hometown in Texas Mrs. Brauner's boardinghouse was far, far away, but it could never have been the boardinghouse in that song for many reasons. The food at Mrs. Brauner's was always varied and delicious, and the boarders never yelled, although at times there was some gentle laughter.

The boarders at Mrs. Brauner's were just as varied in their personalities and ages as the food she served; they were not

at all like one family. They sat close together at the dining-room table, though. In fact, they sat so close together that sometimes one would get a jab in the ribs when his neighbor was cutting his steak.

This family-style feasting was not new to me. I had been raised in a family of seven children, and we all used to sit around such a table, my mother at one end and my father, who always said the blessing, at the other. In another way, perhaps, our meals were like Mrs. Brauner's, for at our table there were nearly always present several guests who were not members of our family. Traynham Pitts was sometimes there, and my father often brought a stranger home for dinner from the cotton gin. One day he brought to dinner a farmer who turned out to be very religious. When my father offered him the honor of saying the blessing, this man let go with loud shoutings to the Lord. Anyone could have heard him a block away. He must have thought the Lord was either a great distance from our table or stone deaf. My mother started laughing and had to get up and escape to the kitchen to keep from embarrassing our guest. He went on and on, praying louder and louder. We later learned that he was a "hard-shell Baptist," and that that sort of praying was common with them.

At Mrs. Brauner's table there were never less than ten boarders. None of them sat at the same place at each meal. Nor did anyone ever say the blessing. Sometimes one or two boarders would be missing, their places filled by two people the rest of us had never seen before. No one seemed to feel obligated to introduce anyone else. No one felt obligated to speak at all; we were

there to eat. But since we were human beings, there was always much talking.

An old sea captain, who was not a Navy captain, was present. His name was Captain Gillis, and whenever he spoke everyone listened respectfully, perhaps because he spoke so loudly.

One day he happened to be sitting beside a really dignified elderly lady whose name was Mrs. Todd. For some reason Captain Gillis didn't seem to like something on his plate that day, so he politely picked it up with his fork and placed it on Mrs. Todd's plate.

"What are you doing that for?" Mrs. Todd asked with surprise .

"I just didn't happen to want it," the captain answered.

"I don't happen to want it, either," Mrs. Todd said. "At least, I don't want yours."

"Well," the captain continued, "it won't hurt anything being on your plate, will it?"

Mrs. Todd didn't answer.

Another day, I was seated next to Captain Gillis. He turned to me and said, "Young man, what brings you here? Is San Diego your home?"

"No, sir," I answered. "I have just arrived from Texas, but if I had known there was such a beautiful place as San Diego I might have come sooner."

"Beautiful it is, son," he said. "You should enjoy it to the fullest, for it won't be this way long. Because of the climate and the Chamber of Commerce, thousands and thousands of people

208

will flood in. Among them will be smart ones who care for nothing but the dollar. Give them time. They will surely ruin this little paradise. That's for sure!"

A bald-headed man across the table had heard Captain Gillis's remarks. This man looked at me with a smile and said, "Don't believe a word he says. He is a born pessimist. San Diego was not always the way it is now. A few years back it was a flea-bitten, dusty village without any trees. It has grown better and better, and there is no reason why it shouldn't continue to improve."

The old captain sort of growled, and then muttered, "Yes, if you can keep the damn promoters out."

When we got up from the table that night and strolled into the adjoining room, the dignified Mrs. Todd moved near me and whispered, "That old captain is very uncouth." Later she invited me to go with her the following Sunday to the Christian Science Church service.

* * *

Before leaving Chicago, I told Lowell Houser about a book I had read at A&M. The title of the book was *Unknown Mexico*. It was written by a naturalist named Carl Lumholtz, who had traveled from one end of Mexico to the other in the year 1901. His objective was to obtain all the knowledge possible about the different Indian cultures of that country. Lowell must have read that book after I told him about it, for he became fascinated with Mexico.

When I wrote to Lowell from San Diego, he answered my letter immediately, and I was surprised at what he had to say. "What's wrong with our going to Mexico this coming summer?" he wrote. "You say you are returning to Texas the first of June. Why don't I meet you there, and we can then go on to Mexico?"

I answered his letter and said, "O.K., to Mexico we go," even though I had no special place in mind. I imagined we might cross the Rio Grande at Villa Acuña and just keep going west. I knew my old car, "The Swan," would still be available in the shed down at the barn. I also thought Traynham Pitts might be able to go with us. But since I still had several months of art school in San Diego, I put the idea of going to Mexico out of my mind.

One afternoon as I was returning to my room, Odell Lovell came out of his big house with his baseball and two gloves. But this time he had something besides baseball on his mind.

"How about double-dating with me and my girl?" he asked. "We already have a girl for you. I think you two would hit it off. She writes part-time for the *San Diego Sun.* Her name is Eileen Duwire. She even reads books without any pictures in them, the way you do."

"Look, Odell," I said, "I am not interested. There are plenty of girls at the art school if I wanted a date."

Odell was persistent. He just kept it up. "I have a car, and we can all go in it. We can go to the beach. The grunion will be running tomorrow night. We can take a bucket and get some."

I had no idea what a "grunion" was, but for some mysterious reason I finally said I would go. Since I had been determined

210

not to get involved in social life in San Diego, the way I had in Chicago, I have often wondered why I let Odell talk me into going with him and meeting that unknown girl. It would be a "blind date." Maybe my decision to go was because I had always had hovering in the back of my mind a vague image of a black-haired girl I would someday meet.

At times I could almost see that girl. I never did try to see her, but I knew she was there. I had no idea how she got there. I supposed it was some kind of fixation, but I had to admit to myself that I had it, whether I liked it or not. Now it seems to me that it might have been her influence which caused me to give in to Odell.

Late the next afternoon Odell picked me up. We then drove to his girl's house and picked her up. She was a girl of Italian descent, very friendly. As she got into the car, she said, "I'm sure you are going to like Eileen Duwire. She writes on the newspaper."

To be polite I said, "I'm sure I will like her. The question is, will she like me?"

When we arrived at Eileen's two-story house on Essex Street, we all got out and went inside where I was introduced to Eileen and also to her mother. Her mother struck me as having a beautiful and slightly sad face. She reminded me at once of a picture I had seen of George Sand. The picture was in an art history book by Elie Faure, a Frenchman. I had brought that art book along with me to California. Eileen was rather tall, and I noticed she had jet-black hair. While we were in the house she

barely spoke. I got the impression she would rather not be going. I felt the same way, so we had that in common.

When we all got into the car, she changed immediately. She began talking very fast. I was stunned by her voice. I did not understand a word she said; I could only listen to her beautiful voice. Never in my life had I heard a voice like hers.

Finally I began to understand her. She started asking questions, and that made me concentrate on the meaning of her words. "Where are you from?" she asked. I said I was from Texas, but that I had been studying art in Chicago.

Then, to my amazement, she said, "What do you think of me?"

No girl had ever asked me a question like that. I replied, "I think you are nothing but a flapper." That might have annoyed her, but instead, she thought it was funny and laughed. Something had certainly come over me.

Odell took us to the beach. The moon was shining brightly. When we got there he said, "Come on, I've brought two buckets. Let's see if we can catch some grunion." He and his girl got out, but Eileen and I did not move. I did not know what a grunion was, and I did not want to know. I only wanted to stay where I was with that black-haired girl. When she said, "You two go on. We want to stay in the car and talk," I was delighted.

After we had talked for about two hours, I still understood very little of what she had said because I was not able to concentrate on anything but the sound of her voice. You would have thought that once I had heard it, I would then have ceased noticing it, but that was not the case at all. Her voice was like music

212

—but not jazz music. It was like classical music.

When Odell and his girl, Marie, came back to the car, they were barefooted and wet. They had in the buckets some little fish about four inches long.

"So those are grunion, are they?" I said. "We always threw back any fish that were less than a foot long."

Odell said, "But you cook these whole! They are delicious." I couldn't imagine eating such little fish.

When we went back to Eileen's home, I walked to the front door with her. I was still quite stunned, but I did ask her if I might call her on the phone. When she said, "Please do," I almost shouted I was so pleased.

* * *

The girls in the art school appeared different to me the next day, after that blind date with Eileen Duwire. They were still pretty, but nowhere near as noticeable as before. There was one by the name of Rila whom I had almost asked for a date, but I now dropped that idea. All I wanted was for the day to end so I could call Eileen Duwire.

Before going to Mrs. Brauner's for dinner that late afternoon, I went to the hallway phone. I looked in the phone book. I turned to the "D's." I went down all the names, with my finger running over them. I tried the "du's" the double "du's," even the "do's" and the "doo's." But nowhere was there a Duwire or anything like it. I felt sunk. Was I going to lose this girl forever? "Surely," I thought, "she must have a phone or she would not

have said, 'Please do.'" Was I so near that black-haired girl who had hovered so long in the back of my mind, only to lose her forever? I was frightened.

Next morning I went to art school and painted with Katharine Kahle, that pretty young married lady. But I could not concentrate on what I was trying to paint. Late that afternoon, when Odell showed up outside his house, I said to him, "How do you spell the name of that blind date I had? I thought I might call her sometime." I tried not to sound overly anxious.

"Duwire," he said. "D-W-Y-E-R, Eileen Duwire."

"D-W-Y-E-R," I repeated, and then I said the letters over again. "I think I might call her up," I said, casually. But it was all I could do to keep from running to the phone.

Spring in San Diego

CHAPTER XIII

Return to Mexico

On June 2, 1923, Lowell D. Houser from Ames, Iowa, arrived in my hometown by train. Together we went immediately to look for Traynham Pitts. Fortunately he had just left a job in the oil fields when we found him.

Traynham had never met Lowell. I told him Lowell and I had studied together at the Art Institute of Chicago and that he had just arrived from Ames, Iowa, and wanted to go to Mexico with us.

"What part of Mexico?" Traynham asked.

"I was thinking we might get in "The Swan" and drive right to Villa Acuña," I said. "We know that place. We can then just take off, after you have filled your hat full of quarters out of that slot machine. We can take any road going in a westerly direction and see where it leads us. Can you go with us?"

"Sure," Traynham replied. "When do we leave?"

The next day while I was checking over "The Swan" to see that it was in good condition, the thought came to me that we should teach Lowell to drive. Living in a big city so much, he had never learned to drive an automobile. So the three of us got into "The Swan" and drove up town on McKinney Street.

The streets were much improved since the day I had left for California. I drove out into the residential part of town. I then stopped and told Lowell to get behind the wheel. Next, Traynham and I explained how to drive. "The Swan" was a Model T Ford car. To make it go you simply had to push one pedal down. You would then be in low gear. After getting up a little speed, you then took your foot off the pedal. It would come forward, and you would be in high gear. There were just three pedals on that car. One was for both low and high gear, the middle one was for reverse, and the other one was a brake. So Lowell started down the middle of the street in low gear. He had pushed the pedal clear down. I then reached over below the steering wheel and pulled the accelerator down. We began going quite fast in low gear.

"Now take your foot off the pedal," I said. When he did that we went into high gear and began going much faster. Lowell

was doing fine for a beginner, but I noticed that he was driving in the middle of the street, not on the right side.

Soon we were going past the house of an old high-school friend. All along the side of his house were hackberry trees. Suddenly, while going quite fast, Lowell made a right-angle turn, jumped the curb, went into my friend's yard, and maneuvered in and out among the trees, never slowing down. He kept on going until he came to the corner of the house, made another right angle turn to the left, jumped another curb, and entered another street which was at right angles to the one he had started on. He was still going fast.

"Push both pedals down!" I shouted to Lowell. "Push the one on the right and the middle one!" Lowell did just that. The car stopped and coughed, and the motor went dead.

We sat there in silence for a moment. "What did you do that for?" Traynham asked. "You certainly know how to dodge trees!"

Lowell looked a little confused. He then said, "I saw a car coming up the street, and I thought I had better get out of the way. I didn't want to collide with that car."

"Bro Lowell," Traynham said, "we are going to let you be navigator on this trip. Beency and I will be pilot and copilot." And that is the way it turned out on the entire journey.

* * *

With Traynham Pitts driving "The Swan," and Lowell Houser, our navigator, on the back seat, we began our journey to Mexico. We agreed we would stop in San Angelo to greet my brother Hal, the dentist. We would then continue on to Villa Acuña.

The first night out we camped in the same mesquite pasture Traynham and I had camped in when Paul Gee and Nellie were with us. The prairie-dog village in that pasture appeared to be thriving, and this time the prairie dogs were not disturbed by their cousin Nellie, the Airedale terrier.

When we arrived in San Angelo, we went to see my brother in his dental office. I almost believed he was still grinding on the tooth of that same girl he had been working on two years before. Again he was surprised to see us, and again he was slightly annoyed that we had not written in advance of our arrival.

"Now just where are you boys headed this time?" he inquired.

After introducing Lowell to him, I said, "Hal, this time we plan to go straight to Villa Acuña, and from there we are just going to explore. We hope to find a road that leads west or southwest."

"Well," he said, "this time you are not going without me." He left the girl in the dental chair and went to a telephone in the next room. When he came back he said, "You will have to spend the night here with us. Tomorrow morning Elizabeth and I will go with you. My vacation starts tomorrow. Don't worry, I keep

my camping car packed and ready to go. We can be off right after breakfast."

I liked his Tennessee wife, and I was pleased they would be going along. I also thought it might be an advantage to have two cars in case of any kind of breakdown.

Although Hal was noted for being slow, this time we really did get away early the next morning. We stopped for gas in Del Rio, and when we had crossed into Mexico at Villa Acuña, we found a dirt road leading southwest.

After driving about a half-hour, I looked back and could not see Hal's car. I wondered what was delaying him, and I began to drive very slowly. Soon his car appeared behind me, and when he came closer I saw, to my surprise, that there were three people in the car. That was such a mystery that Traynham insisted we stop and find out what that meant. When Hal drove up beside us, we saw that his extra passenger was a Mexican.

"This is Francisco Carranza," Hal announced. "We picked him up in Villa Acuña. He says he knows the road all the way to the head of the Sabinas River. He speaks a little English."

I got out and went over to speak to this young Mexican. I tried to greet him in my poor Spanish. I liked his friendly look, and I thought to myself that he might pose for me in camp.

We continued southwest on a fairly good dirt road through a semi-desert country, hoping to find a shady place for lunch. Since the land was flat and no trees could be seen in any direction, we stopped for lunch right in the road.

I wanted to learn more about our Mexican guest who was threatening to take the navigator's job away from Lowell. *"Senor*

Carranza," I said, "*¿De dónde viene usted?*" ("Mr. Carranza, where do you come from?")

He answered in his kind of English: "Me come Monterrey. *En la guerra* me fight *con Pancho Villa.*" ("In the war me fight with Pancho Villa.")

"*¿Cuánto tiempo con Pancho Villa?*" I asked. ("How long with Pancho Villa?")

"Me fight two year *con Pancho Villa.*"

"Did you ever kill anybody?" I then asked.

"Me no kill," he said. "Me get behind big rock, me point rifle at sky, *y* joot *y* joot *y* joot. No kill." He then laughed. I liked this young man. And from him I got the idea he was not a typical soldier, for he tried to avoid hurting anybody, even in battle.

The first town we came to was Zaragoza, a flat place where large fig trees were growing above many adobe walls. Their limbs hung down into the street, and the trees were loaded with black figs. I soon learned that my brother was extremely

fond of that fruit. He took off his hat and proceeded to fill it with those luscious figs. He then pointed to an adobe building. I looked and saw a big sign on the building with the word "Dentista."

Hal put down his hat with the figs and said, "Come with me. I'd like to meet that dentist." As we walked toward the dental building, I stopped to read a notice tacked to a telephone pole. In big letters at the top was the word *"Pronunciamiento."* Underneath was a long message, and under that a long list of Mexican names. I was able to read only about a third of the message, but I did make out that the person who wrote it was violently opposed to President Obregón, calling him a murderer and other names. The date on the notice was August 1922, and it was signed, "Francisco Murguía."

When I pointed it out to my brother and read what I could of it to him, he said, "Yes, our papers were full of stories about that. This General Murguía was shot shortly afterwards when he was captured somewhere south of here by Obregón's forces. He had run into a Catholic church to escape, but he was dragged out and shot in an Indian cemetery. I read all about that."

"Gosh," I said, "that was in 1922, just last year. That wasn't long ago!" We saw other copies of that *pronunciamiento,* most of them mutilated, on walls and on other telephone poles.

When we went into the dentist's office, I tried to explain to the Mexican dentist that my brother was also a dentist and that he practiced dentistry in Texas. The Mexican was very cordial, but since Hal spoke no Spanish and I very little, we remained talking only a minute or two.

After we had left the dentist's office and Hal had retrieved his hat with the figs, we started walking to our cars. Hal said, "Good night! His equipment is so primitive! He works his drill with his feet!"

* * *

Since Lowell and I fully intended to go down into the interior of Mexico after this trip was over, the story about General Murguía was a bit disturbing to us. We were quite sure the revolution in Mexico was over, but we now thought we should learn all we could about the political situation in that country.

After we had found gasoline in Zaragosa, we departed from that quiet, sunny Mexican town before lunch and continued driving westward. In the far distance, on the horizon, we could see a band of pure blue-violet. Francisco told us that band was the Burro Mountains. It appeared to me to be very far away, and I wondered if we could ever reach it.

In the late afternoon we arrived at a complex of barns and houses all built of adobe brick. This proved to be the Mariposa Ranch where we had the good fortune to get gasoline again.

The next day we drove to the town of Musquiz. "How could such a place be so charming," I thought, "and yet so isolated from all the rest of the world?" Actually, it may have been well connected in the ways of those times. The fact that it was in a remote part of Mexico, which was itself remote because of the recent long revolution, made Musquiz seem to me almost as isolated as the moon.

When we left Musquiz we turned northwest and drove toward the head of the Sabinas River. Eventually we passed through a Kickapoo Indian village where the houses were made of straw. A short distance beyond the village we came suddenly upon a sight so beautiful that its image would remain with me the rest of my life.

A field of white rocks was spread out over an area of about one acre. This area was surrounded on three sides by tall, wild pecan trees. Within the area, clear cold water was springing up among all the white rocks. The water was just bubbling up right out of the ground. And fifty yards downstream, a river could be seen.

Where we stood, we were witnessing the birth of a river. We were standing upon the head of the Sabinas. All of us were so thrilled by this beautiful sight that we wanted to camp at that spot, under the nearby pecan trees. We knew, however, that we would have to get permission from the Kickapoo Indians.

With my poor Spanish I told Francisco what we wanted. Lowell and I went with him into the village where bright-colored rags or textiles seemed to decorate all the straw houses. We located some of the elders of the village and asked if we might camp at the place we preferred. That place was only a stone's throw away. These Kickapoo men did not hesitate to give us their answer. It was, "No." But they graciously offered to send with us one of their number to show us a nice camping spot some eight miles down the river. The man they sent was the only one among them who could speak a little Spanish. This gray-haired

Indian took us to a beautiful place, shaded with tall pecan trees, right on the bank of that swiftly flowing, clear stream.

* * *

From our camp on the bank of the Sabinas River the land sloped gradually upward, forming a hill. Hugging the crest of the hill was a row of low adobe houses with straw roofs. As I gazed at those houses, thinking that I might try to make a painting of them, a boy on a gray donkey started down a trail toward our camp. When he came close I was surprised, for obviously he was neither an Indian nor a Mexican. He was, unmistakably, a black boy. That pleased me, for I assumed that I would be able to ask him some questions in English.

As I walked to meet him I said, "Hello, there. That's a fine donkey you are riding."

The boy stared at me and said nothing, so I spoke to him a little louder, thinking that he might be deaf: "That's a fine donkey you are riding. Do you live in one of the houses on the hill?"

He continued to stare at me and then said, "*No comprendo.*"

I knew what those words meant. This little boy did not speak one word of English; his language was *puro espanol* (pure Spanish).

"*¿Como se llama usted?*" ("What is your name?") I asked, to which he responded, "José."

Continuing to speak with him, I learned that the houses on the rim of the hill marked the beginning of the village of

Nacimiento. Apparently we were camping on the edge of that village. I also learned from José that all the inhabitants of the village were like himself. It was a village made up of black people who spoke only Spanish. I did not learn until much later that Nacimiento was founded by runaway slaves before the Civil War.

I knew that the Spanish word *nacimiento* meant "birth," and I assumed that here it referred to the river that was being born and born again constantly, only a few miles away. Had I known at that time that the village had been established by runaway slaves, I would have appreciated the name as doubly appropriate: the place of the birth of freedom for those former slaves.

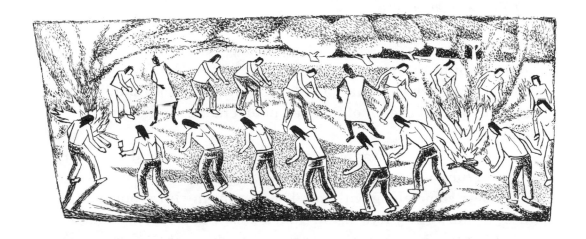

CHAPTER XIV

Camping on the Sabinas

The Indian who guided us to our camping spot on the
Sabinas River seemed to believe he had been assigned to us
permanently, for he stayed on and on. We were happy to provide
him with food, of which he ate little. His sleeping quarters ap-
peared to be wherever he became sleepy, right on the ground.
Francisco also slept on the ground, but he and our new guide
kept a good distance apart. That was because of Poete, the
Kickapoo Indian. Poete soon let me know that he considered
himself superior in every way to Francisco, the Mexican. Poete

would point at Francisco, smile, and say to me, *"No buena; muy floja."* ("No good; very lazy.") Like me, with my poor Spanish, he used the "a" and the "o" of Spanish noun endings indiscriminately.

The morning after our arrival, I took my rod and reel with artificial lure and went to the river to see if there were any fish in it. Poete came along with me. The instant my lure touched the water in the swiftly flowing stream, a bass was hooked. While I reeled the line in, other bass continued striking at the lure until I had reeled it in with the fish on it. This river, so much like the Devils River, was overpopulated with hungry, angry fish. You never had to cast twice to catch one.

Poete had never seen a rod and reel, an artificial lure, or a plug. He had been carrying a spear about four feet long while going along the river with me. He now indicated that he would like to show me how he caught fish. Walking to a place where the river was quite narrow and deep, he pointed out to me some large fish about three feet below the surface. I recognized them as channel catfish. He drew back his arm and let fly with the spear. Then, pulling on the cord attached to his spear, he landed a fish that was about three feet long. He told me he never tried to catch the bass.

When we returned to camp with our fish, I placed my rod and reel against the trunk of a pecan tree. A few moments later I looked and discovered that my fishing tackle had disappeared. Poete was also gone. I hoped he had not decided to take my fishing gear and escape back to his village. I need not have worried about that. In a few minutes he returned with my reel in the

worst backlash I had ever seen. Poete simply could not cast with rod and reel. He had been willing, and he had tried; however, his many skills did not include that of casting a line with an artificial lure.

The next afternoon I told Elizabeth I was going out to get her some quail for dinner. I took my 20-gauge pump shotgun, which had just four shells in it, and started walking away from the edge of the village. Again Poete came along. We had walked no more than a quarter of a mile when we discovered that the ground ahead of us was crawling with quail. A dirt trail led through low brush. Many quail were running ahead of us along the trail.

Since I only had four shells left of the box I had started with on this trip, I now put sportsmanship out of mind. I was only hunting quail for our dinner. I began to walk slowly forward as the quail ran along the trail ahead of me. I was waiting until three or four birds would get into line, for I hoped to get them all with one shot. As I waited, Poete kept motioning to me. He had a rock in his hand and wanted me to let him throw it. Finally I said to him, *"Muy bien, tíralo."* ("Very well, throw it.") He threw his rock and hit a quail in the head. It spun around and lay still on the dirt trail. Since there was no noise the other quail were not disturbed at all.

I thought to myself, "Now that I have Poete along, maybe I don't need any shotgun shells." As I was thinking that, a number of quail, quite close together, came into view. I raised my gun, and when I thought I had at least two in my sight, I fired. Quail flew up on all sides. They continued to fly up, one covey after another. There must have been thousands of them.

When Poete and I went to pick up the two quail I hoped to find, we picked up twelve instead. That was enough. He and I dressed the quail, and that night Elizabeth served us all a delicious quail dinner.

* * *

From Poete's point of view, I had now become a mighty man for getting game. With my rod and reel I could pull fish out of the river, and with my gun I could kill twelve quail at one shot. And in addition, I could speak Spanish about as well as he

232

could. So Poete became my sidekick. Apparently he believed I should begin hunting much bigger game, for he said to me, *"Mucho oso. Vamos al cañón. Hay mucho oso."* ("Many bear. Let's go to the canyon. There are lots of bear.") I knew this would be out of my line. I doubted that a bear could be killed with bird shot, and furthermore, I never liked to kill any game larger than a duck. I decided I had better turn this over to my brother Hal. I knew also that Hal had brought along a .30-30 rifle.

"Poete wants us to go bear hunting," I told Hal. "He says he knows a canyon where there are lots of bear, and he wants to take us there. In all your hunting I don't believe you have ever shot a bear, have you?"

"I never have shot one," Hal said, "but I sure would like to get a shot at one."

Traynham overheard what we said. The idea of shooting a bear was very appealing to him. He came forward and said, "Let's go with Poete. Let's get a bear, by all means! I hope you will let me do the shooting."

I now could not help recalling Traynham's early history as a marksman. When we were very young, John Corley let him shoot his pump air gun at that little black dog we thought we wanted to kill. Traynham took aim, but missed by at least two yards. We suspected he had missed on purpose. Then later, my father always let Traynham shoot at ducks because he enjoyed seeing Traynham miss the ducks clean. I remembered that even then I suspected he just didn't want to kill those ducks. Now he wanted to do the shooting again, this time at a bear. I felt quite sure he was thinking how he would get a kick out of shooting at

a bear and missing it. That was why I was hoping Hal would let him do the shooting.

Five of us—Poete, Francisco, Traynham, Hal and I—piled into Hal's car and drove toward the mountains. Lowell did not come along because he was off making pencil drawings. Poete guided us until we entered the mouth of a canyon where we stopped the car. From that point we would have to walk. Poete then tried to explain the strategy of the bear hunt.

Since he had told me the bear would be big and dangerous, I felt it was necessary to understand him clearly. Unfortunately Poete's language was Kickapoo, which I didn't speak. My language was English, which he didn't speak. We both knew only a little Spanish, and with that we would have to try to communicate. Then I would have to tell the hunter what he was to do because neither Hal nor Traynham could speak any Spanish.

First, however, we had to decide about the hunter. Who was to carry the rifle and shoot the bear? I wanted Traynham to do that, so I said to Hal, "You know, Hal, this could be dangerous.

Whoever is going to do the shooting should be a crack shot, and I know that Traynham is. When we were just kids, he shot the streetlight out with his air gun."

"O.K., then," Hal said, "I'll give the rifle to Traynham."

Traynham took the rifle, and we started up the canyon, Poete in the lead, Traynham next, with the rifle, and Hal and I last. Francisco stayed in the car, just as Poete had told me he would. Poete had said to me, *"La Mejicana, muy floja. No viene."*

234

("The Mexican 'woman,' very lazy. Does not come.")

Soon we were climbing along a steep trail next to the left side of the canyon. We were getting higher and higher above the bottom of the canyon, which was becoming much more narrow. Since the trail was also quite narrow, we had to walk single file.

Looking ahead, I saw that the canyon made a turn to the left and that it would be impossible to see what might be on the trail around the corner. I whispered to Traynham, "You had better get ahead of Poete; you had better take the lead. What if we met a big bear coming down this trail around the corner? You ought to be in front of Poete, with the rifle."

Traynham looked ahead and saw that the trail really did turn so that there was no way of knowing what was around that corner. He then whispered to me what he was thinking. "Look," he said seriously, "I think Poete had better stay ahead of me. If a bear was around that corner, Poete could slow him down until I had time to cock my rifle and get it to my shoulder."

At that point Poete stopped and began whispering to us, *"Oso, muy abajo. Fondo del cañon."* ("Bear, way below. Bottom of canyon.") I noticed that Poete had a big rock in each hand. He went on to tell us that soon he would toss the rocks down into the canyon, and if the bear was down there it would start scampering up the other side. It was then that the hunter with the rifle would see the bear and shoot him.

After we had gone a few more paces in silence, Poete, who was still walking just in front of Traynham, tossed the rocks down into the deep, narrow canyon. Immediately I saw the bushes down there start shaking, and then I got a glimpse of a

235

big black spot rushing downward through the underbrush. Traynham raised his rifle to his shoulder and fired. I saw crumbling rocks begin to fall from the spot he had hit, about twenty yards above the black spot.

We retraced our steps down to the car, where we found Francisco extremely excited. *"Un oso muy grande pasó por aquí, corriendo, corriendo muy rapidamente!"* he said. ("A big bear passed this way, running, running very rapidly.")

That was the end of our bear hunt. Traynham Pitts had again managed to avoid killing an innocent member of the animal kingdom.

* * *

Lowell and Elizabeth had remained behind while the rest of us were away on the big bear hunt. Although we came back to camp minus a bear, they both were anxious to hear all about our adventure. There is something about a bear that seems to excite the imagination.

After I had told my version of the hunt, Poete motioned that he wanted to talk to me in private. I went over to where he was standing and said, *"¿Qué quiere, Poete?"* ("What do you want, Poete?")

He then asked if I would do him a favor. Would I drive him to a house on the far side of the hill in Nacimiento? He informed me there was going to be a big Indian dance in his village and that he needed some liquor. He said he could get the

liquor in that house in Nacimiento. He went on to say, *"Es contra la ley, indio Kickapoo comprar licores. Tengo amigo que me lo da."* ("It is against the law, Kickapoo Indian to buy liquor. I have friend who will give it to me.")

I did not want to get involved in such an illegal matter, but I decided I could not gracefully refuse to take him to the place. The two of us then drove around the hill and through several streets until we came to a house with a high adobe wall around it. Poete said that was the place. He got out of the car and disappeared through a wooden gate in the adobe wall. Soon he returned with something wrapped in newspapers. I saw him look cautiously in all directions as he emerged through the gate. He hurriedly jumped into the car, and as I drove away he tore some of the paper from around the object he was carrying to show me what it was. To my surprise, it was only a bottle of Carta Blanca beer. I thought to myself that Poete would not be able to get very drunk on that. It was obvious he valued the bottle partly because it was illegal for him to have it. Apparently the Mexican officials, who drank plenty of tequila themselves, believed it advisable that Kickapoo Indians remain sober.

While driving back to camp, I learned from Poete that the dance was a religious ceremony and that it would go on all night long, until sunrise. When I asked if we might be permitted to watch the dance, he said we could, but that we should stand with the black people, who would come from Nacimiento to watch.

Shortly after dark we all drove in one car to the Indian village. Poete and Francisco rode on the running boards of the

car. The instant we arrived where the blacks were standing, Poete jumped down and quickly disappeared.

We could hear drums beating somewhere nearby. Because of the noise of the drums and the loud talking and laughing among the blacks, the sound of the birth of the Sabinas River, only a short distance away, could not be heard.

Two fires were burning about fifty yards away between us and the Indian village. The fires were about forty feet apart. I noticed that the black spectators did not approach the fires. They remained back about fifty feet from them. We all just stood there, waiting. There were no Indians in sight, only black people.

While the drums continued a monotonous rhythm, we began to hear muffled voices singing or chanting. Since no Indians were visible, it was clear that the chanting was in some underground room nearby. Suddenly there appeared out of the darkness several Indian men. They were nude to the waist and painted snow-white, both body and face. Immediately they began a jumpy, jerky dance that proceeded around the two fires. The singers now came from underground and joined in the dance.

The chanting dancers went from one fire to the other, around them and back and forth. This went on and on. Although the rhythm of the drums and chanting was extremely monotonous, I saw that it was contagious, for the blacks began to sway and dance with it. At intervals, Indians who were not in the dance would throw brush on the fires. This lighted up the entire area. I was then able to see that many of the black spectators were healthy-looking young girls.

After the monotonous chanting had been going on a couple of hours, all the blacks were chanting and stomping. Eventually a number of the girls could not restrain themselves. Although uninvited, they fell into line with the Indian dancers. They kept the same rhythm as that of the Indians, but it seemed to me they added more vitality to it.

After several hours we got into our car and drove back to camp. Poete had told me the dance would continue until sunrise, and since there would be no deviation in it, we felt we had seen and heard it all. But I was thinking that someday, because of that mixed dancing, there were going to be many Indian blacks in Nacimiento, and lots of black Indians on the Kickapoo reservation.

* * *

If I had not been with my brother Hal on this trip, I would have done more painting. Those low adobe houses on the crest of the hill above our camp were very paintable, and so was the Kickapoo village. I might even have been able to paint some pictures showing the Indians among their straw houses. And, of course, we were camping under big pecan trees, the same kind I had tried to paint on the Devils River. But Hal was such an avid hunter and fisherman that I let him entice me into going hunting with him time and again. It was a wonder to me that I had been able to persuade him to let Traynham Pitts shoot at the bear.

Now he wanted me to go wild-turkey hunting with him. He believed he knew where wild turkeys were roosting in some tall pecan trees down the river only about a half-mile from our camp. While the turkeys were foraging away from the river during the day, Hal had found signs on the ground that proved they roosted high above in the trees. He wanted me to get up before daylight and go with him to that place. He would take his rifle and I, my 20-gauge shotgun. I had never shot at a wild turkey. In fact I did not like to hunt anything that big, but I decided I should go. By now, however, I was beginning to feel frustrated by my neglect of painting, so I arranged for Francisco to pose for me when I got back. Francisco had a strong Mexican-Indian head, especially when he had on his big straw hat. He said he would sit still for me, and that made me feel better about going with Hal.

Next morning we arrived at those tall trees while it was still dark. Hal had told me how wild those birds were, that we should not speak a word, not even whisper, while creeping silently under the trees. After we were well beneath the trees, Hal stopped and pressed my arm. I assumed he meant we were then right under the roosting turkeys. I kept still and quiet while Hal moved on about fifty feet from me.

Just as day was breaking, I was startled by a turkey hen making her strange up-and-down sort of call. That call, breaking the silence just at dawn, struck me as being very stimulating and beautiful. But it turned out that it was Hal who had made the strange noise. He had with him what he said was a "turkey call." Why he blew it when the wild turkeys were already right

240

over our heads, I don't know, but the instant he blew his call the turkeys began to fly wildly out of the trees. I had never heard such a fluttering noise. It was all around me. I even felt wind being churned by the wings of the turkeys. The birds were close to me, yet invisible. From all the noise and fluttering of big wings, I judged there must have been dozens of turkeys. Even so, for at least five minutes I saw not a single one. Finally, a hundred yards or more away, I did see, through a break in the foliage and against the early-morning sky, a wild turkey flying. It was silhouetted against the light, its neck and head stretched straight out from its big black body. After I had seen the turkey in flight, daylight came on fast, and with it the knowledge that all the wild turkeys had flown away.

Hal and I had now been on two great hunts together: a bear hunt and a wild-turkey hunt. We had nothing to show for those hunts other than our memories of them.

The afternoon of that same day, I made a quick sketch in oils of Francisco's head. All the time he was posing he kept telling me of his battle experiences with General Pancho Villa, and how, as a common soldier, he had managed not to kill anybody. In that way Francisco, the soldier, was like Traynham Pitts, the hunter. We did not know it at the time, of course, but while Hal and I were returning from our turkey hunt that morning—the morning of July 20, 1923—assassins were murdering Francisco's retired General Francisco (Pancho) Villa.

As the time approached for our departure, I was intrigued to think of the strange setting of our camp. Only eight miles away, cool clear water bubbled up over a half-acre of rocky land

to become immediately a swiftly flowing river. Near that place a Kickapoo Indian village of straw houses spread out among trees and underbrush. And over a low hill from our camp was the adobe village of Nacimiento whose inhabitants were Spanish-speaking black people.

The Sabinas River, like the Devils River in Texas, was swarming with fish. Quail seemed to be everywhere a short walk from our camp, and wild turkeys roosted in the high pecan trees down the river. Not far away, in the canyons, black bear were hiding. I had seen one running ever so safely from Traynham's gun. But the Indians and the blacks seemed to make little use of all this wild game around them. Poete would occasionally spear a big catfish and hit a quail in the head with a rock, but since he did not have a rifle, the deer and the bear lived on in safety. As far as I could see, all these people lived on the corn, squash and beans they grew, and on the few goats and sheep they raised. However, since Poete wore buckskin pants, I assumed that he managed, in some way, to get a deer every now and then.

Several days had passed since the Indian dance, and we had seen nothing of Poete. We had not even seen him that night dancing with the other Kickapoos and the blacks. I felt sure he had not been drunk, for he could not have achieved that condition on only one bottle of beer. Now that we were packing our cars to leave camp and go back to Texas, I regretted that I had not at least made a drawing of him.

Poete must have been quite an old man despite his strength and vitality. He wore his iron-gray hair down to his shoulders. There was absolutely no color about him, except

perhaps for his skin which was a deep, dark gray-brown. He wore a shirt that might once have had a little blue in it, but if so it had lost all its brightness. His shirt hung down over the top of his pants which were made of a warm-toned, light-gray buckskin. I doubt if he ever wore any sort of underwear to protect his skin from the roughness of his pants. But with all his grayness and primitive attire, his appearance was imposing. When you looked at Poete, you knew you were seeing a person of importance.

Both cars were now loaded, so we all climbed into our respective places. Traynham was to drive "The Swan." I was next to him in front, and Lowell, our navigator, was in the back seat. Hal, Elizabeth and Francisco, in Hal's car, were already moving away. We planned to go as directly as possible to Villa Acuña and then on toward San Angelo. From there Traynham, Lowell and I would return to Mexia.

As Traynham started the car forward, Lowell touched my shoulder and said, "Look! There is Poete!"

I looked back and saw him, in all his grayness, leaning against the trunk of a pecan tree where we had camped. "Stop the car!" I shouted to Traynham. "We have to say good-bye to Poete."

The three of us got out and went back to where he was standing. "We are leaving, Poete," I said. "We wish you were going with us."

I knew this was another case when, after meeting a person and liking him, you know you will never see him again. Paul

Gee always said on such occasions, "I wish to God I had never knowed you."

I went back to our car and pulled out my rod and reel and a couple of artificial lures. I handed it all to Poete.

"Poete," I said, *"quiero darle este regalito. Con práctica puede usarlo."* ("Poete, I want to make you this little gift. With practice you can use it.")

Poete smiled and answered, *"Quiero una cosa más—su dirección."* ("I want one other thing—your address.")

I wrote my Texas address on a piece of paper and handed it to Poete. None of us shook hands with him. Somehow I felt you didn't do that with Indians. We all just patted him on his shoulder as a way of saying good-bye and of showing that we appreciated him. We then got into our car and started our journey home.

*　　*　　*

As on many other occasions while driving through this foreign land, I was now thinking of that black-haired girl back in San Diego, California. I could almost hear her voice. Would my leaving her turn out to be like my leaving Poete—never to see her again? "Not if I can help it," I said to myself. Weeks had passed since Traynham, Lowell, and I had headed west in the old open Ford touring car. I knew she knew my address. Would there be a letter waiting for me? That question kept popping up in my mind. It seemed to me we were traveling only to get to the place where a letter would or would not be waiting. I even had to

look through that question to see anything. It was as though I had on eyeglasses with that question, "Will there be a letter?", written on the lenses. I had to look through those words to see anything else.

When we finally reached Villa Acuña, Hal and Elizabeth insisted we go to a Mexican restaurant for lunch. There was a bar in that place, and Traynham kept looking at the space behind it. He now turned to me and said, "You have been away at art school. How about you and Lowell and me staying over here a couple of days while you paint that fat nude woman? I bet I can sell the idea." I said to him that I might now know how, but I really had to get back home. I wanted to keep on going east without even stopping for lunch, but of course I had to stop.

With my lunch I ordered a bottle of Carta Blanca beer. When it came I saw that it was the same type of bottle Poete had got from that adobe house in Nacimiento. It was an unusually large bottle. During lunch I drank the whole bottle, and I changed my mind about the effect it might have had on Poete the night of the Indian dance. I now knew it was possible that he had gone off to sleep during that dance, for when I got up from the table Traynham had to guide me back to our car. I was very unsteady on my feet. They simply got out of my control.

We crossed the Rio Grande River out of Mexico, a country for which I now had a strong and strange attachment. We continued to drive east and did not stop until we reached Comstock, Texas, where we filled our tanks with gasoline.

By this time my feet were my own again, and although those words were still on my invisible eyeglasses, I could see

quite well beyond them. As we pulled up to the gas station, I noticed something that gave me the excited feeling which comes from recognizing the unexpected. Hanging around the station was the biggest hound dog I had ever seen, and I knew I had seen that same dog before. It was none other than Nellie's old boyfriend. It was the father of her half-breed puppies, conceived here in Comstock, Texas, and born over three hundred miles farther east, in Mexia, Texas.

Pointing to the dog, I said to Traynham, "Did you ever see that hound dog before?"

Traynham took one look. "That old son of a b!" he said. "He is still hanging around here trying to overpopulate the state of Texas with hounds. That's all he thinks about."

"That and eating," I said. "But actually I doubt if he thinks about either. He just does his thing."

"In any case," Traynham added, "I wish I had some way to tell Nellie we saw one of her many admirers." Nellie had by then given birth to a total of thirty-three pups, of several different nationalities.

We did not stop over with Hal and Elizabeth in San Angelo, but continued on east toward Traynham's and my hometown. When we arrived there, I let Traynham off at a barbershop on Commerce Street.

I'm going to get a haircut before going home," he said, "unless you think I should take out a dog's license instead."

Lowell and I went on to my home. When Queen rushed out to greet us, I was almost afraid to ask if there was a letter for me.

"You have two letters!" she said. "Both from California!"

I tried not to appear excited. The letters were really there. They had been waiting for me, and they both were from that black-haired girl. They were unusually thick. When I opened them I saw that, in addition to the letters, each envelope was stuffed with newspaper clippings.

<p style="text-align:center">* * *</p>

Fifty miles east of my hometown was a little two-room red house set among large oak trees on what was left of our family's pre-Civil War plantation. In addition to the beautiful oaks, wild persimmon and sassafras trees surrounded the house, and from the house, old abandoned fields extended in all directions. There could not have been a more beautiful spot from the point of view of an artist. My family and the family of my father's brother retained that land for sentimental reasons and as a place to go for picnics or to hunt quail in the fall and wild ducks in the wintertime. In fact, the house was called "The Hunter's Den."

Lowell and I now went to that place to draw and paint until Lowell received his allowance check which he expected would arrive within three weeks. While we were there, I became the cook and Lowell, the dishwasher. Each day we kept busy trying to practice what we had learned at the Art Institute of Chicago, but we were eager to be off to Mexico again. Each day, also, we walked to the road where our mailbox rested on top of an oak post.

The day arrived when Lowell's check was in the mailbox, and along with it, a letter from that black-haired girl. Again the envelope included newspaper clippings. These were mostly *New York World* columns written by Heywood Broun. I was not very interested in all those newspaper clippings, but I read them nevertheless, thinking that perhaps she might have something in mind to discuss with me at some future time.

Since I knew of no way to see her soon, I was determined to keep in touch with her through letters. I would tell her about Poete and Francisco, about the Kickapoo Indians and Nacimiento. I would illustrate my letters with drawings. And when Lowell and I went again to Mexico, I would bombard her with letters. Perhaps in that way I might somehow establish a bond that would keep her from escaping until I could get back to California.

There was another letter in the mailbox that day. It had been written by a professional letter writer. In those days, professional letter writers sat at tables just outside of post offices in Mexico to write letters for illiterate Mexicans and Indians. The

professional writers charged a small fee for their services. This letter had been dictated by my Kickapoo Indian friend, Poete.

"Estimado Don Everardo," it began. *"Tengo el honor de escribirle a decir que llevé a Muzquiz una venada viva muy chiquita con manchas. Quería mandarla a usted como regalito, pero no pude porque se prohibe enviar animales por la causa de la enfermidad que se llama 'aftosa.' Sinceramente, su servidor, Poete."* ("Esteemed Mr. Everett: I have the honor to write to you to say that I carried to Musquiz a very small doe with spots. I wanted to send her to you as a small gift, but could not because to send animals is prohibited because of the disease called 'hoof-and-mouth disease.' Sincerely, your servant, Poete.")

Apparently Poete had somehow managed to catch a small fawn with spots, and he had wanted to send it to me as a gift. I remembered the day we had departed from camp near Nacimiento. Poete had asked for my address. He must have been thinking then that he would send me a gift. Lowell and I were very touched by his letter.

* * *

It was early in September, 1923, when Lowell and I stood on the railroad platform in my hometown. It was the same platform from which I had boarded a train north for Chicago. We now had tickets that would take us south to Guadalajara, Mexico. Our train would pass so near my old school, Texas A&M, that I would be able to see again all the familiar buildings. But

we would keep on going until we reached that unknown, foreign city. We knew Mexico had just emerged from a long and bloody revolution. We did not know another revolution would break out there in one month. We did not know exactly why we had decided to go to that place, but we certainly knew it was our destination.

As we approached the Mexican border, Lowell said, "When we were camped up near Nacimiento, I kept noticing how easily little José rode that burro. I think I am going to get me one when we are settled down there. I have already figured out how I can attach a cloth sack to a burro, to carry my pencils and paintbrushes."

The End

Cotton Pickers, East Texas

Cora Alexander's Cabin

Goat Tails and Doodlebugs has been published in a trade edition of 1000 copies. A limited edition of 150 specially bound and numbered copies has also been published. —1993

Cotton Pickers, East Texas (1923) and *Cora Alexander's Cabin* (1923) represent the artistic style of Everett Gee Jackson just prior to his moving to Mexico in 1923 where he painted for five years. *Texas Bluebonnets* (1922), done in another early style, was a favorite of Jackson's mother. She surprised him by entering it in a competition in Texas while he was away. The influence of the Mexico years can be seen in *Spring in San Diego* (1929), an example of the style of painting for which Jackson ultimately was known.